DRAWING WORKBOOKS
PEOPLE

Bruce Robertson

NORTH LIGHT BOOKS

Cincinnati, Ohio

Dedication
To Frank Wood –
unique art teacher

Acknowledgement
Many of the drawings are by students or members of
the Diagram Group. Wherever possible they have
been acknowledged in the captions. The following
are acknowledgements to libraries and museums who
own the works of famous artists.

p10 Henry Fuseli: Victoria and Albert Museum, London
p24 Albrecht Dürer: Staatliche Museum, West Berlin
p36 Vincent Van Gogh: I V W Van Gogh
p37 Rembrandt: British Museum, London
p41 Juan Gris: Museum of Modern Art, New York
p43 Albrecht Dürer: Museum of Fine Art, Boston
p46 Vincent Van Gogh: Fogg Museum, Harvard University, Massachusetts
p52 William Blake: Tate Gallery, London
p60 William Hogarth: Mansell Collection, London
p62 Kathy Kollwitz: Fogg Museum, Harvard University, Massachusetts
p63 Ben Shahn: Museum of Modern Art, New York
p63 Hans Holbein: Royal Library, Windsor Castle, England

Artists
Joe Bonello
Alastair Burnside
Helen Chapman
Richard Czapnik
Stephen Dhanraj
David Gormley
Brian Hewson
Richard Hummerstone
Mark Jamil
Lee Lawrence
Paul McCauley
Victoria Ortiz
Kathleen Percy
Anne Robertson
Jane Robertson
Michael Robertson
Graham Rosewarne
Guy S. R. Ryman
Ivy Smith
Mik Williams
Marlene Williamson
Martin Woodward
Zoë Ullstein

Typographer
Philip Patenall

Editors
Carole Dease
Damian Grint
Denis Kennedy

Cover illustration by
Graham Rosewarne

© Diagram Visual Information Ltd 1987

First published in Great Britain in 1987
by Macdonald & Co (Publishers) Ltd
London & Sydney

ISBN 0-89134-230-3

Published and distributed in the United States by North
Light Books, an imprint of F&W Publications, 1507 Dana
Ave., Cincinnati, OH 45207

DRAWING WORKBOOKS

THIS BOOK IS WRITTEN TO BE USED.
It is not meant to be simply read and enjoyed. Like a course in physical exercises, or any study area, YOU MUST CARRY OUT THE TASKS TO GAIN BENEFIT FROM THE INSTRUCTIONS.

1. READ THE BOOK THROUGH ONCE.
2. BEGIN AGAIN, READING TWO PAGES AT A TIME AND CARRY OUT THE TASKS SET BEFORE YOU GO ONTO THE NEXT TWO PAGES.
3. REVIEW EACH CHAPTER BY RE-EXAMINING YOUR PREVIOUS RESULTS AND CARRYING OUT THE REVIEW TASKS.
4. COLLECT ALL YOUR WORK AND STORE IT IN A PORTFOLIO, HAVING WRITTEN IN PENCIL THE DATE WHEN YOU DID THE DRAWINGS.

Do not rush the tasks. Time spent studying is an investment for which the returns are well rewarded.

LEARNING HOW TO DO THE TASKS IS NOT THE OBJECT OF THE BOOK, IT IS TO LEARN TO DRAW, BY PRACTICING THE TASKS.

WORKBOOKS ARE:
1. A program of art instruction.
2. A practical account of understanding what you see when you draw.
3. Like a language course, the success of your efforts depends upon HOW MUCH YOU PUT IN. YOU DO THE WORK.

- Drawing is magical, it captures and holds your view of the world. Once produced, the drawing is eternal: it says 'This is how I see the world at this place in this time.' It tells of your abilities and your circumstances.
- Drawing is a self-renewing means of discovering the world, and its practice is self-instructive. You learn as you go along and you improve with practice.
- Drawing is a universal language understood by everyone. It is also a concise and economical way of expressing reality and ideas.
- Drawing is a state of consciousness. You lose yourself in the drawing as you become involved in your responses to what you see. It has a calming effect when you feel depressed, agitated, ill or dissatisfied. You are outside yourself. Everyone can learn to draw. Be patient and try hard to master the skills.

TOPIC FINDER

Drawing PEOPLE

Drawing is selection — it is looking and seeing, and missing out the unnecessary. Drawing is not copying nature — it is commenting on it.

Portraits are universal. We know what faces are like, so we can judge how much of a person's character is seen in their face. This is easily proved when an inexperienced artist copies a photograph of a famous person. The drawing doesn't look like that person. Somehow, what is in the person is not in the drawing.

Try to identify what makes a particular person unique. Your drawing should reveal their inner quality.

The individuality of a person can be captured by observing an expression or mark. It is the intimacy of the closely observed detail.

Drawings reveal your sympathies or antipathies to the subject matter you study, so do not be afraid to have opinions about what you see.

CONTENTS

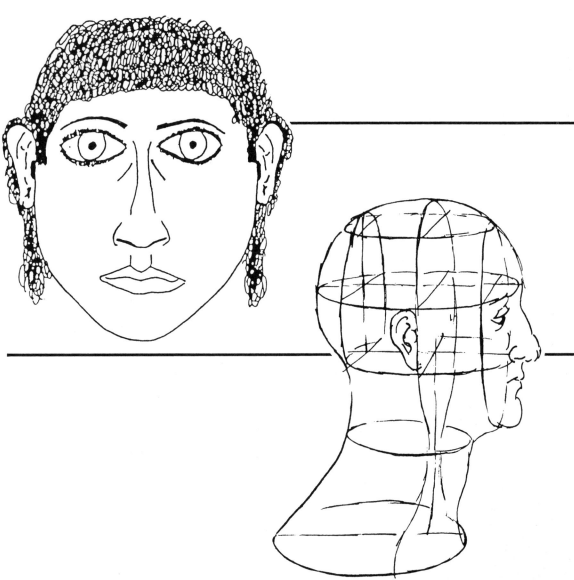

Chapter One LOOKING AND SEEING

Chapter Two UNDERSTANDING WHAT YOU SEE

CHECKING YOUR PROGRESS

You may not do all the tasks in the order they appear in the book. Some require you to research sources of photographs or other artists' works, some direct you to museums and art galleries, and some may be done quickly while others can only be completed when you can devote more time to their study.

To help you keep a record of your completed Tasks, fill in the date against each numbered Task in the space given beside it.

TASK 1	TASK 31	TASK 61	TASK 91
TASK 2	TASK 32	TASK 62	TASK 92
TASK 3	TASK 33	TASK 63	TASK 93
TASK 4	TASK 34	TASK 64	TASK 94
TASK 5	TASK 35	TASK 65	TASK 95
TASK 6	TASK 36	TASK 66	TASK 96
TASK 7	TASK 37	TASK 67	TASK 97
TASK 8	TASK 38	TASK 68	TASK 98
TASK 9	TASK 39	TASK 69	TASK 99
TASK 10	TASK 40	TASK 70	TASK 100
TASK 11	TASK 41	TASK 71	TASK 101
TASK 12	TASK 42	TASK 72	TASK 102
TASK 13	TASK 43	TASK 73	TASK 103
TASK 14	TASK 44	TASK 74	TASK 104
TASK 15	TASK 45	TASK 75	TASK 105
TASK 16	TASK 46	TASK 76	TASK 106
TASK 17	TASK 47	TASK 77	TASK 107
TASK 18	TASK 48	TASK 78	TASK 108
TASK 19	TASK 49	TASK 79	TASK 109
TASK 20	TASK 50	TASK 80	TASK 110
TASK 21	TASK 51	TASK 81	TASK 111
TASK 22	TASK 52	TASK 82	TASK 112
TASK 23	TASK 53	TASK 83	TASK 113
TASK 24	TASK 54	TASK 84	TASK 114
TASK 25	TASK 55	TASK 85	TASK 115
TASK 26	TASK 56	TASK 86	TASK 116
TASK 27	TASK 57	TASK 87	TASK 117
TASK 28	TASK 58	TASK 88	TASK 118
TASK 29	TASK 59	TASK 89	TASK 119
TASK 30	TASK 60	TASK 90	TASK 120

LOOKING AND SEEING

This first chapter starts you on the path of examining your subject and your view of it. Looking is not seeing, nor is seeing necessarily understanding. There are twenty-eight Tasks designed to draw your attention closer to the process of looking at the subject and helping you to be aware of how your drawing is the result of your observations.

● The first two pages, 6 and 7, contain the most important idea in the book – transcribing a solid, three-dimensional world onto a flat two-dimensional surface.
● Pages 8 and 9 offer methods of checking what you see.
● Pages 10 to 13 explain how we 'read,' or interpret, the light and dark areas of a subject.
● These are followed by pages 14 and 15 which offer a method of constructing your drawing by finding points on the subject, and then transferring these to your drawing.

● Next, pages 16 and 17 offer twenty examples of how the subject's personality, the artist's view and skills, and the medium of the drawing interrelate to produce the drawing.
● Finally page 18 recommends you to make a notice board in your room onto which you regularly display your work so that you and other people may, from time to time, re-examine the drawings and review your achievements. Time and practice are two certain ways to improve your abilities.

What we think we see may not be what is there. All drawing converts solid objects to a flat shape. The physical world consists of changes in color, shape, volume, texture and shading. You must describe all you see with lines and built up tones, using only a flat surface and with the normal drawing instruments of pencil, pen, chalk or brush. Drawing is interpreting what you see.

TASK 1
Seeing solids
Wrap elastic bands or ribbons around a glass jar, bottle or tumbler. Do a careful pencil drawing, observing how the bands turn around the sides of the solid form. Try to draw the parts nearest to you in a heavier line than those furthest away. This exercise helps you to see the solid quality of objects.

TASK 2
How do you interpret?
Copy a photograph of yourself or copy a portrait in a newspaper or magazine. Try to do the drawing approximately the same size as Task 1. Do not simply copy the shadows and lighting, use the photograph to understand the volume of the head.

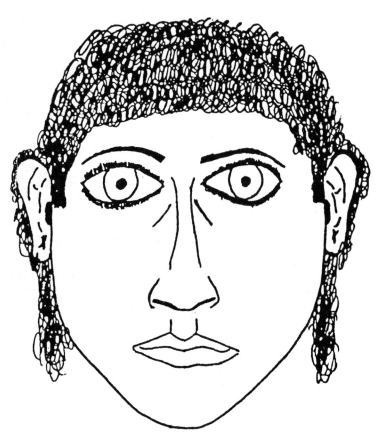

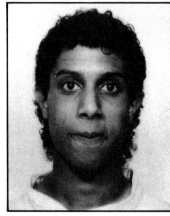

Steve's self-portrait
Left, drawing by Steve, aged 16, is clearly recognizable from his photograph (above) taken later, but he has failed to see the volume his head occupies. Steve has drawn a map of his head.

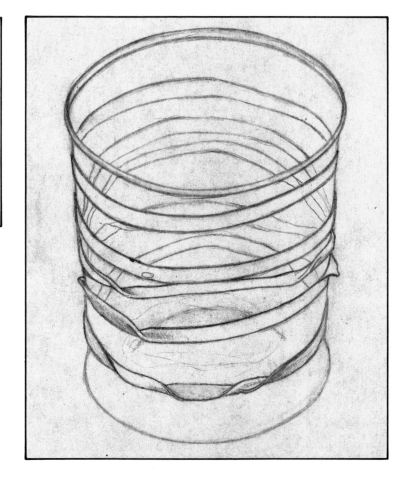

Lee's glass
Right, drawing by Lee, aged 17, is very well depicted. You can see the empty space inside the glass.

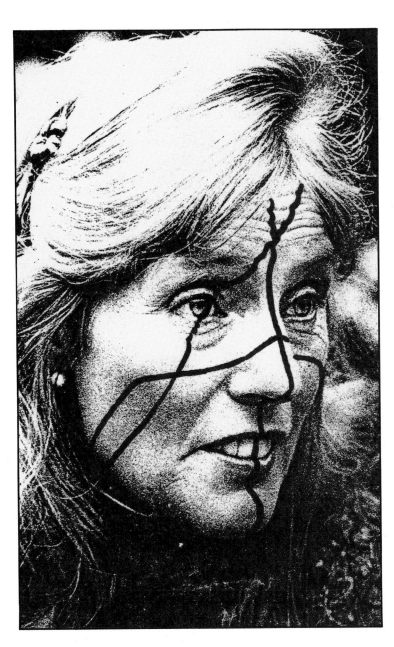

Tracking
Left, felt-tipped pen lines have been drawn over a photograph to explore the rise and fall of surfaces. This is made simpler by choosing a clear, well-lit subject.

TASK 3

Understanding volume

Collect large photographs of faces from magazines and newspapers and, using either a soft pencil, ballpoint or felt-tipped pen, draw lines across the faces as if there were tracks on the surface. This will reveal the 'bumps and hollows' of solid forms.

TASK 4

What do you see?

Sit in front of a large mirror with a constant light in front of you either to the left or right side. Draw your portrait approximately 8 in (20.3cm) high on whatever paper you feel comfortable with. Pencils make the easiest tool as they have a wide range of different marks – other drawing implements require more practice.

Breaking out

Right, Rembrandt's portrait of a fellow Dutchman was drawn more than 300 years ago. Not only does it successfully capture the form of the head – but the hand reaches out beyond the surface and into the space on the page.

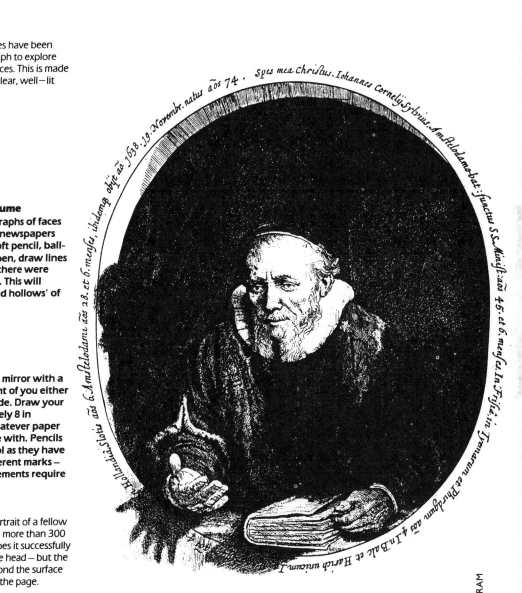

When beginning to master drawing, it is useful to rely upon some simple checking devices. All are based upon the idea that it is easier to record irregular shapes if they are related to regular ones. When viewing the subject against a vertical or horizontal edge, you must only use one eye. To reveal the difference in viewing with two eyes, hold out a pencil vertically. Retaining the pencil in the same position for both tests, view an object with the left eye only, then the right. Notice the 'shift' in vision.

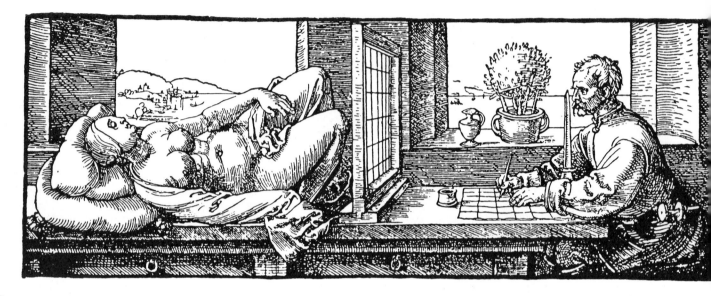

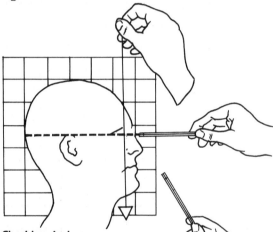

Checking devices
Most artists use some sort of checking device to help them test their judgement of horizontals, verticals and angles.
A plumb line is a simple device for checking vertical alignments.
A pencil held out horizontally can be used to check distances or alignments across the subject.
A frame or grid behind the head helps you to judge relationships of shapes.
A pencil held at a parallel direction to the shape to be drawn assists the definition of angles.
All these devices are intended as aids and, if used constantly, will greatly increase your accuracy and confidence.

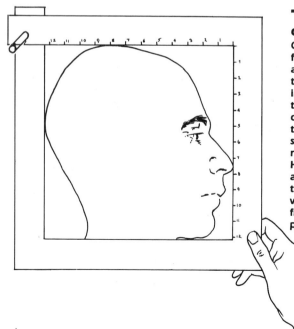

TASK 5

Checking shapes
Cut two identical right-angle frames from card, each with sides of approximately 10 in (25cm). Mark the sides of the card at regular intervals. Using paperclips, join the two cards together to form a square or rectangle similar in proportion to the area of your drawing. Draw the same shape with marks at the same regular intervals on your paper. Hold out the frame in front of you and view the subject through it, then carefully plot the points where the figure touches the frame's edge and mark the same points on your drawing.

Framing your view
Above, many artists have used a grid onto which they have plotted their drawing. Many construct a frame through which to view their subject. Here, the artist keeps his eye in a fixed position to the marker, then, viewing the shapes through a net of squares, records the patterns onto the grid. The drawing becomes a grid of squares, each containing a group of irregular shapes.

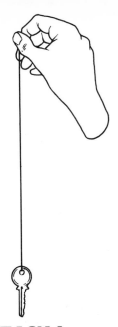

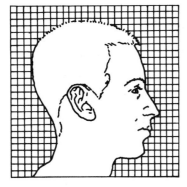

TASK 6
Make a plumb line
The simplest way to check points in a vertical line is to test their positions against a hanging cord. Make your own 'plumb line' by attaching a key to approximately 18 in (45.7cm) of thin cord. Hold out the hanging line at arm's length against the subject and view the subject through one eye. Locate two points on the subject, one above the other, and plot them on your drawing.

TASK 7
Checking your work
To check the accuracy of your work, place tracing paper over the photograph you selected in Task 2 and draw a pattern of squares over the picture. Repeat the pattern on another piece of tracing paper over your drawing. Check that the vertical and horizontal relationships in both are similar.

TASK 8
Portrait shapes
Sit your subject comfortably in front of a window frame, paneled door, or any surface with regular horizontal and vertical lines. Fix in your mind's eye the relationship of some of the points on the head to points on the surface behind. For example, the chin's furthest extent, the top of the head, the angle of the nose. Using tracing paper over the grid (right), carefully plot the shapes against verticals and horizontals on the background. During drawing, use the grid to examine the relationship of different features within the head to each other, checking vertical alignments with a plumb line and horizontal ones with a pencil held out.

©DIAGRAM

Light and shade

Light and shade have always been used by artists to describe the form of objects. Our eyes 'read' the dark and light areas of a drawing to explain its features. Light normally falls from above and from the left or right sides, producing shadows and highlights. By observing carefully the direction of light, you will be able to judge the extent to which surfaces protrude or recede.

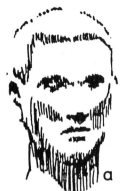 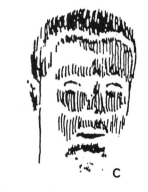

a b c

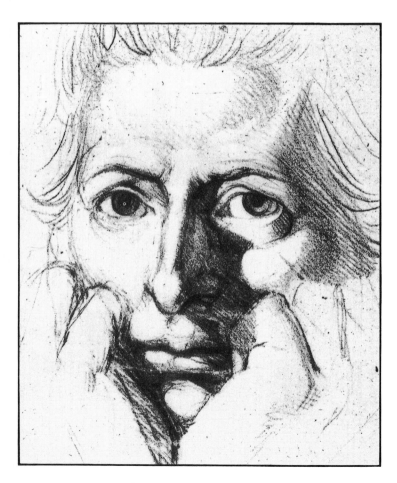

Shadow shapes

Left, this drawing by the 18th-century artist Henry Fuseli uses the strong effects of shadows to describe the protuberance of his nose and lips. The single light source, possibly a candle, helps to create a strong and clear description of the forms of his face.

Directional light

Above, three drawings of a head describe the source of light as coming from (**a**) above, (**b**) the left, and (**c**) below. Each drawing is of the same head and the different results are produced from our interpretation of the lighting effects.

TASK 10

Understanding light and shade

From newspapers and magazines collect photographs with dramatic lighting effects. These are often on the entertainment pages.

Negative and positive

Negative descriptions seldom explain forms satisfactorily as we are accustomed to seeing shapes as the result of light areas created by a light source. Right, a drawing describing the forms as we normally see them. Far right, a reverse, negative version of the same drawing, in which the viewer has difficulty in understanding the forms.

TASK 9

Negative is not the opposite to positive

Using a soft felt-tipped black pen, fill in the areas of shadows on a portrait in a newspaper or magazine. On a tracing overlay, fill in the remaining white areas to produce a negative of the photograph. Compare the two.

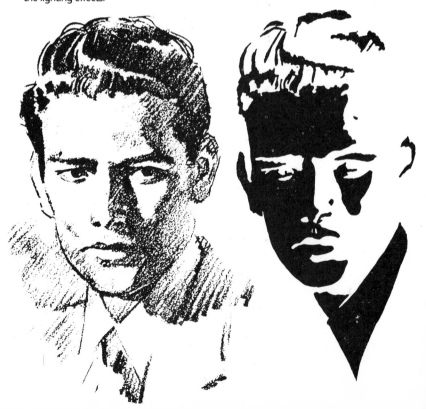

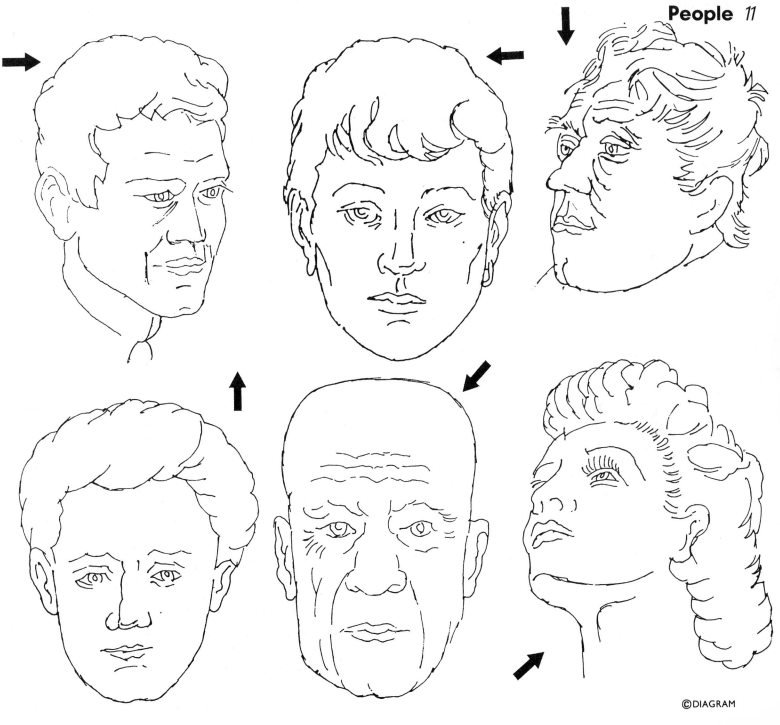

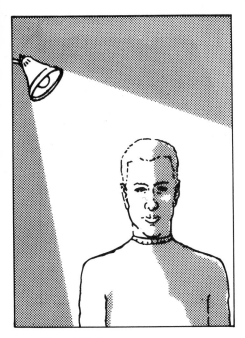

TASK 11

Exploring lighting effects

Sit a model in a comfortable position and light the figure from one source. Use an office desk anglepoise lamp as its beam can be directed easily and its position moved with ease. First draw the head by only shading in the shadowed areas. Retain the position of the model but move the light to a new position, and redraw the same details. Compare your two drawings.

TASK 12

Shadows make forms

Place a piece of tracing paper over each outline drawing on this page and shade in the faces, imagining the source of light to be coming from the direction of the arrows.

©DIAGRAM

We seldom see shapes as separate parts of a drawing. The shapes are 'read' by us as a subject. We superimpose our preconceptions. This is an uniquely human characteristic. Animals do not normally respond to a photograph of another animal. They see only the flat patterns of tone. When drawing a subject you must see it in terms of both independent patterns and, at the same time, as a form.

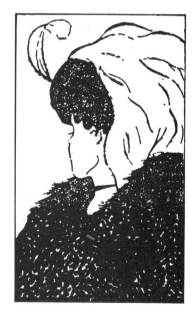

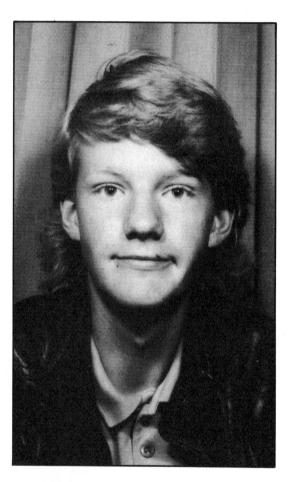

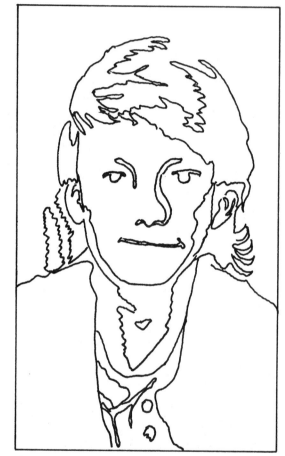

Double meaning
Above, seeing two meanings in one drawing. A young lady with a low neckline, or an old woman with hunched shoulders. Both are correct 'readings.' By adding spectacles or a cigarette (opposite), only one meaning is possible.

Clues to understanding
Above, at first glance these shapes do not convey any impression of a face. They are just shapes. When you turn the page upside down the drawing is clear. Images need to be explicit. Vase (right) could be two people talking.

TASK 13
Simplifying shapes
Artists very often narrow both eyes and squint at subjects to reduce the patterns to simple forms. Try this when studying a real subject.

TASK 14
Simplifying patterns
Mike, aged 16, drew outlines around the stronger tonal areas on his photograph (above left). He then filled these in to produce a tone drop out of his portrait (opposite left). Try this exercise on one of your tone drawings or on a photograph.

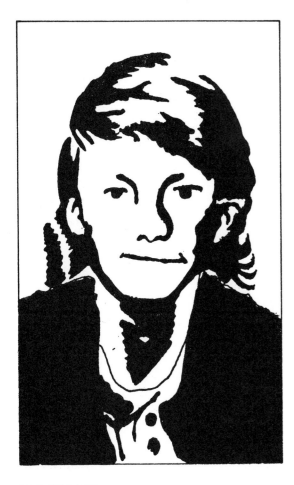

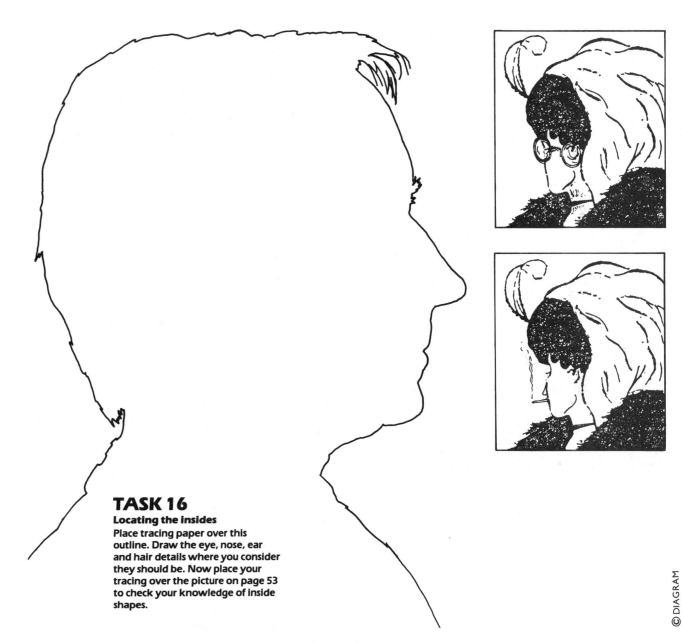

TASK 15

Testing your shapes

Cut out the silhouettes of heads from newspapers and turn them over. With a black felt-tipped pen, fill in hair and other features on the back of the cutting.

TASK 16

Locating the insides

Place tracing paper over this outline. Draw the eye, nose, ear and hair details where you consider they should be. Now place your tracing over the picture on page 53 to check your knowledge of inside shapes.

When drawing a subject, do not rely on your natural ability to draw the relationships of the parts correctly. Artists very often cross-check their work relating one point on the drawing to another by lines or dots. They build up a network of marks into the patterns of the subject. Always remember that it never spoils a drawing to double-check its accuracy.

 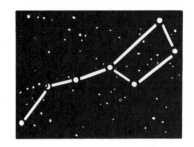

Coordinates make patterns
Left, the stars appear to be in random display in the sky. Very early in man's history, groups were linked up into a pattern to form memorable relationships and add recognition. This is the Plow, with and without the links.

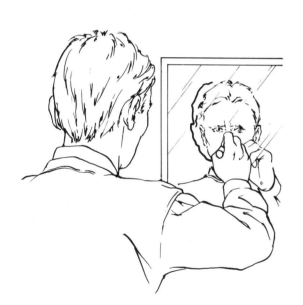 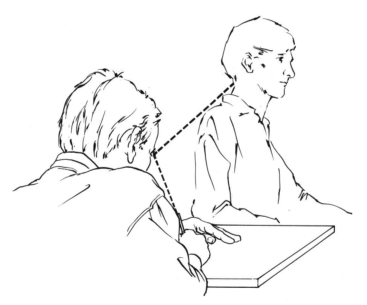 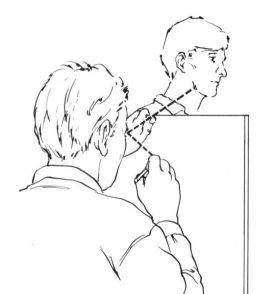

TASK 17
Through a mirror
What we see, and what we think we see, and what is really there, are not always the same. For example, what size is your reflection in a mirror? To test the accuracy of plotting, use a wax crayon or felt-tipped pen and draw your reflection directly on to the mirror. Compare the positioning of the parts with those in your self-portrait drawn as Task 2.

TASK 18
Direct transfer
All drawing is transferring what you see on to a flat surface, and many inaccuracies are the result of the difficulties of this transference. The subject and your paper should be as close to parallel as possible, so you just flick your eyes from one to the other.

Try doing a drawing with the paper at right angles to the view of the subject (above left). Then do a drawing with the paper surface at right angles to your view (above right). In the former, each mark requires you to move your head, in the latter (the correct method), each mark only requires you to transfer your glance from the subject to the surface.

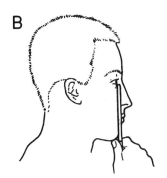

A

B

C

TASK 19

From drawing to reality

You can use the relative proportions of the features to help you place the ear correctly when you are drawing a head from the side. First check the proportions on your own head. Your eyes occur halfway up your head, and the top of your ear is on the same level as the center of your eye (**A**). Measure the distance from your eye to your chin (**B**) and compare it with the distance from your eye to your ear (**C**). You will find that the distances are the same. You can then use this principle – that the distance from the chin to the eye equals the distance from the eye to the ear – to draw your subject's ear in the correct place.

TASK 20

Point to point

Having carefully drawn the outline of a face, measure the distance on your drawing from chin to eye (a). Transfer this distance horizontally to a point within the head (b). This then establishes the position of the ear (c). Imagining these three lines will help when drawing other details such as hairline, cheekbone, and nostrils.

Building links

The drawing (far right) is an assembly of built-up points. Like the plotting of stars, these patterns are the result of linking each small item to the other local parts.

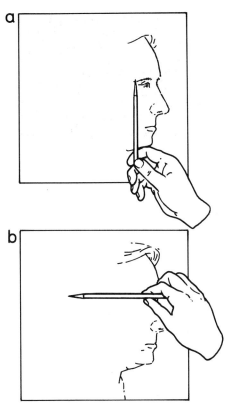

a

b

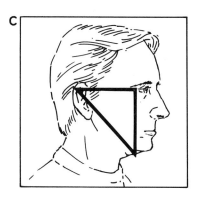

c

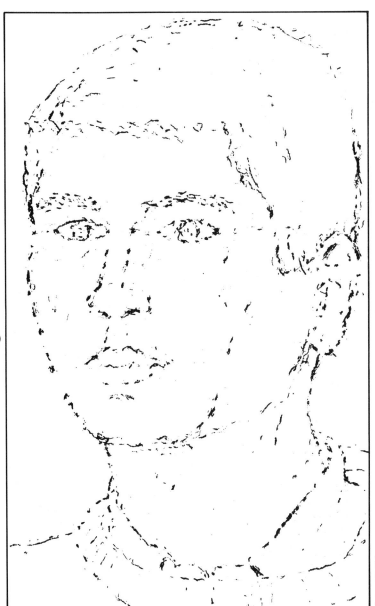

©DIAGRAM

16 Diversity

There are four factors which interrelate in a drawing. The subject's personality, the artist's view, the artist's skills and the medium. Although the basic elements of a head are common to all humans, the various combinations of minor differences of features are infinite. People come in all sizes and shapes, colors and textures. Studying people offers you an enormous variety of subjects.

The artist's view of the subject is the consequence of education, social norms and personal reactions. The artist's skills are a result of self-training and instruction.
The medium very strongly influences the end result. A drawing of a person on a notepad, bank note, memorial plaque, medical chart, satirical cartoon...each describes a person in a different way.

Variety
These two pages contain twenty examples of the wide variety of ways of describing the human head.

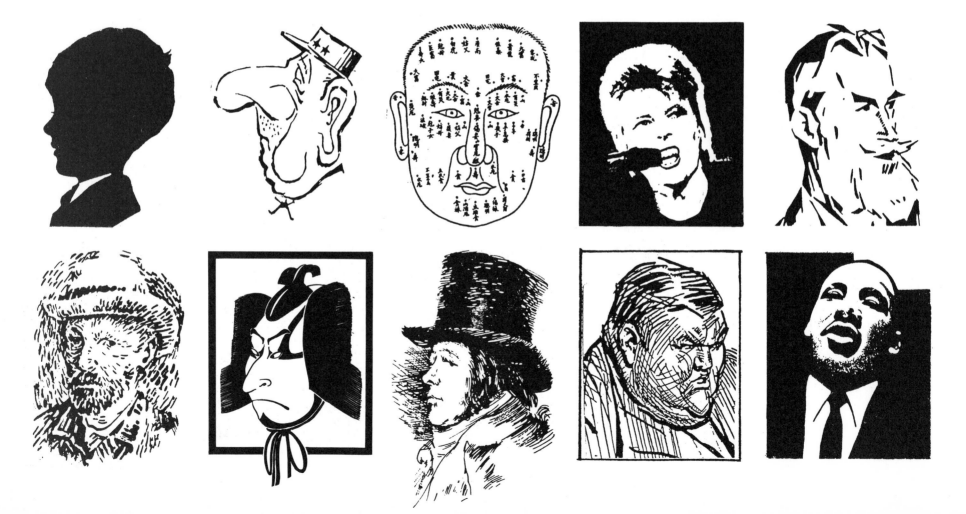

TASK 21
Human variety
Collect examples from magazines and books of faces with character.

TASK 22
Artistic diversity
Collect examples from magazines and books of drawings by artists of faces where their view of the subject has been a strong element in the drawing.

TASK 23
Drawing variety
Using a public library's resources, look at drawings by a famous artist when he was young, and compare it with examples of his artwork from later life.

TASK 24
Reality
Keep a collection of objects with drawings of heads – coins, bank notes, stamps, posters, advertisements in newspapers. Collect as many as possible.

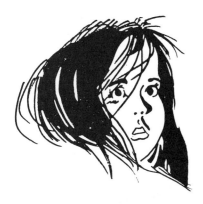

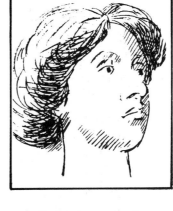

©DIAGRAM

All in the mind

It is hard to hold thoughts of form, shapes, light and shade, patterns and unique variety in mind all at once. It is harder still to apply all these and in addition overcome your initial inability to record all these aspects in your drawing. The sooner you make your mistakes and discover your weaknesses, the sooner you will be able to correct them.

TASK 25

Make a notice board

Your work is evaluated by reviewing it in public. Never be afraid to expose yourself to ridicule. Every drawing is worth considering on its merits, irrespective of the circumstances of its production and artistic merit. The most important task in this book is for you to make a notice board on which to display your drawings. You will be amazed how interesting your work is after a while.

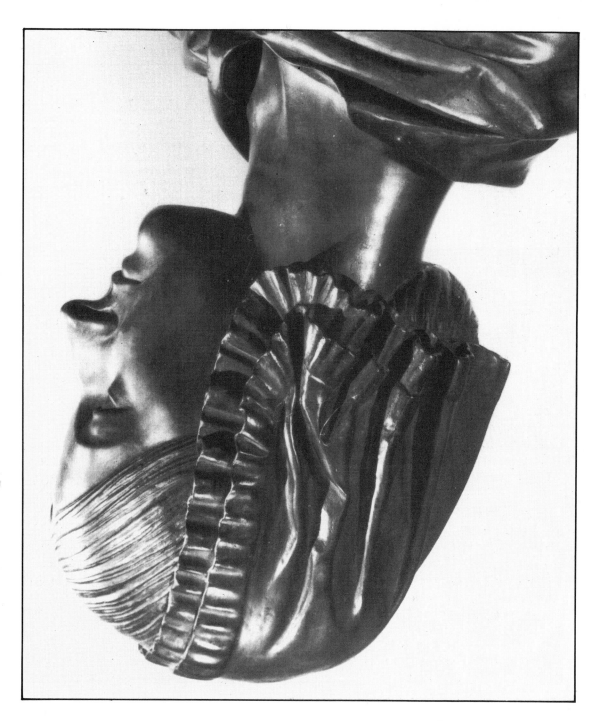

TASK 26

Check for common mistakes

Re-read the text on each page and see how it relates to Tasks on other pages.

TASK 27

Test for accuracy

Copy the tones and forms of the photograph of the sculpture (left). Then turn your drawing and book upside down and compare them.

TASK 28

Cross-consideration

Using Task 5, check its accuracy against Task 8 and then its tonal patterns against Task 11.

UNDERSTANDING WHAT YOU SEE

This chapter contains thirty-two Tasks to help you understand what you see. The knowledge you bring to your drawing helps you examine the subject. More understanding of the basic features of the head enables you to search out clues as to the overall form of the head. Drawing is not copying what you see – it is understanding what you see and recording your views of your understanding.

- On pages 20 and 21 you will be helped to think of the head as if it were encased in a net of lines that travel over the surface and reveal the convolutions.
- Pages 22 and 23 present the head as though it were carved from a block of solid material. The features are presented as a series of hollows and facets.
- Pages 24 and 25 take you into the head, the bones and muscles that from the inside produce the basic structures.
- Pages 26 and 27 show that to understand the head's unique characteristics you must learn the relationship of the parts to each other and to the whole, and also how to measure the proportions of the head.

- The next two pages, 28 and 29, describe the bumps and hollows of the individual parts – the eyes, nose and lips.
- Pages 30 and 31 take you on a trip around the head to the sides and back.
- Pages 32 and 33 draw you closer to the surface to examine the qualities of texture on youthful or aging skin and hair.
- Finally, the Review on page 34 helps you to go over common mistakes made from lack of understanding of the basic proportions and features of the head.

An artist can indicate form by using lines, drawn like the texture of fine hairs, to follow the contours of bumps and hollows. Lines drawn closely together form darker tones than those drawn further apart, and this optical effect creates light and dark areas. When using this technique, it is vital you always think of the solid forms you are overlaying with lines. The result will miraculously reveal the volumes and masses you are describing.

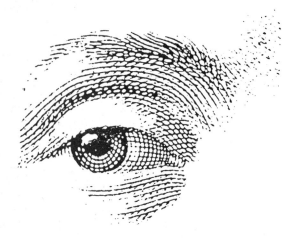

Directional lines
Above, this drawing of an eye is created by a series of parallel lines, running along the direction of the forms. Like plow furrows on a hill, the lines flow along the ridges and hollows. This technique is very often used in etchings and engravings where the tones have to be created by building up multiple layers of lines. In the drawing of Churchill's head (far right on opposite page), the artist used a brush and the ink strokes flow across the forms like the texture of bark on a tree trunk.

Mapping a head
Right, the drawing describes a head by the technique of contours. Each line is of connected points of equal height on the face. This method, which is usually used in cartography to describe hills and valleys, has been produced here by a computer scanning a person's face. To produce a drawing by this method, you would have to examine very carefully 'altitudes' on the face, and you would have to ignore colors, textures, tones and light and shade effects.

TASK 29
Encasing volumes
Place tracing paper over the self-portrait (Task 2) and carefully plot center lines, making an altitude map of your face.

A linear net
Below, the three drawings show how a series of parallel lines following the contours of a face, when overlayed, can create a sense of form. Drawing (**A**) is of vertical lines running down a face, drawing (**B**) is of horizontal lines. As both were drawn on tracing paper, it was possible to overlay them and the resulting combination (**C**) reveals the hollows and bumps of a face.

A B C

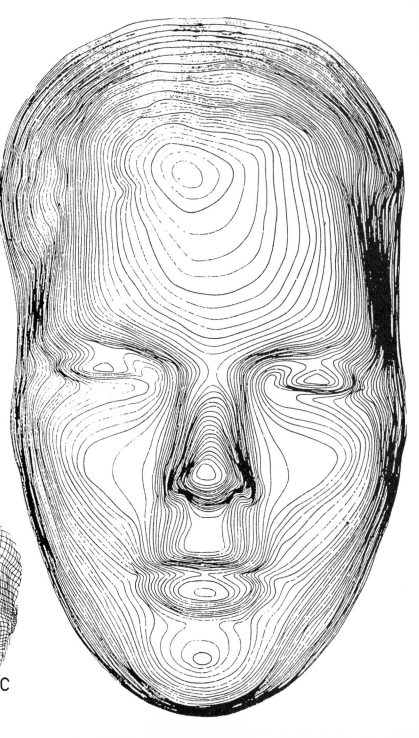

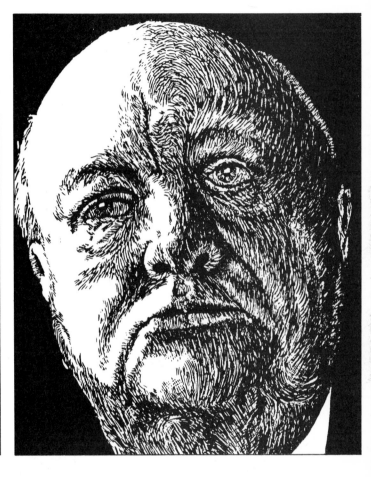

TASK 30

A linear net

Place tracing paper over the drawing (above) and draw a series of parallel horizontal lines following the forms on the face. Repeat the exercise with vertical lines. The resulting grid should, when lifted off the drawing, retain some of the features of undulation.

TASK 31

Mapping forms

Place tracing paper over the drawing (above) and draw a series of vertical and horizontal lines over the face. With a drawing like this, very little indication of form is suggested, so you must think your way round the features.

Directional ticks

Above right, the head was drawn by building up rows of ticks as if the face had been plowed with parallel lines. These lines, like the bark on a tree, help describe the form.

TASK 32

Plowing surfaces

Place tracing paper over your self-portrait (Task 2) or over any large photograph, and re-draw using the directional tick solution to describe forms.

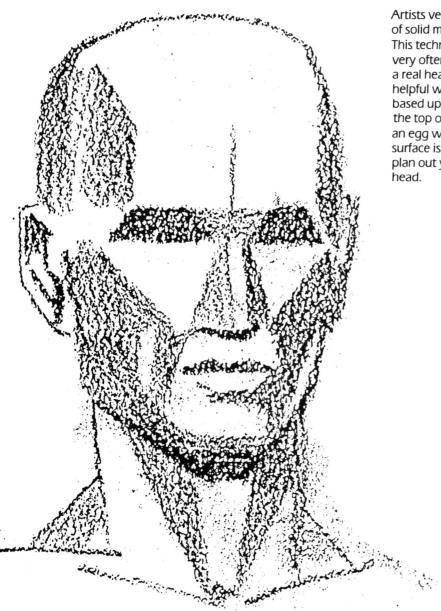

Artists very often try to see the head as a block of solid matter, a sculptured, carved-out form. This technique, although it has its limitations, is very often useful to keep in mind when drawing a real head. Some kind of an assembled block is helpful when planning to draw a head not based upon observations. A ball jammed into the top of a bucket is a simple construction, and an egg with the features marked out on its surface is another. Both these solutions help you plan out your first thoughts when sketching a head.

Carved out
Below, this drawing was produced over 400 years ago by Albrecht Dürer. Artists producing paintings and drawings on a flat surface have always been aware of the carved, sculptured qualities of the human head. This drawing is much easier to 'read' because of the simple planes of the form, than if it were sketched without concern for volume.

Abstract man
Left, this drawing is an idea of a head. No person has these ridge places on their face. Each has the unique, particular details of themselves. Nevertheless, the description of the structure is useful to bear in mind when recording a real person.

TASK 33
Boxing in
Work on newspaper or magazine photographs with a soft pencil or crayon in order to change the surface of a photographic face to flat planes.

TASK 34
Carving out
Using Task 2, your self-portrait, or a photograph or drawing in a newspaper or magazine, produce a drawing in any medium which portrays the surfaces as if carved out of wood.

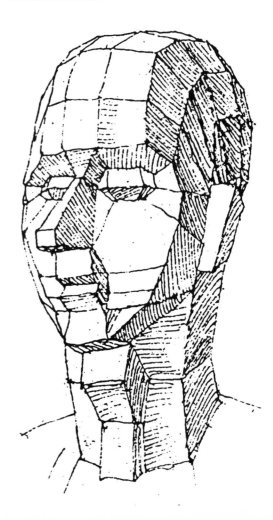

TASK 35

Egg head

Sketch the positions of the face and ears on an egg shape, and imagine their relationships changing as you view the egg from different viewpoints.

TASK 36

Bucket and ball head

Draw a ball. Draw three lines around the ball (**A**). Add a bucket to the bottom of the ball and extend two of the lines from the ball onto the sides of the bucket (**B**). Draw a circle on the side of the ball at the point where these lines cross (**C**). Remove a circular side segment (**D**). You now have a basic construction for an imaginary head, onto which you can plot the positions of the features (**E**). This construction is constant at whatever angle you view the imaginary head (**F**).

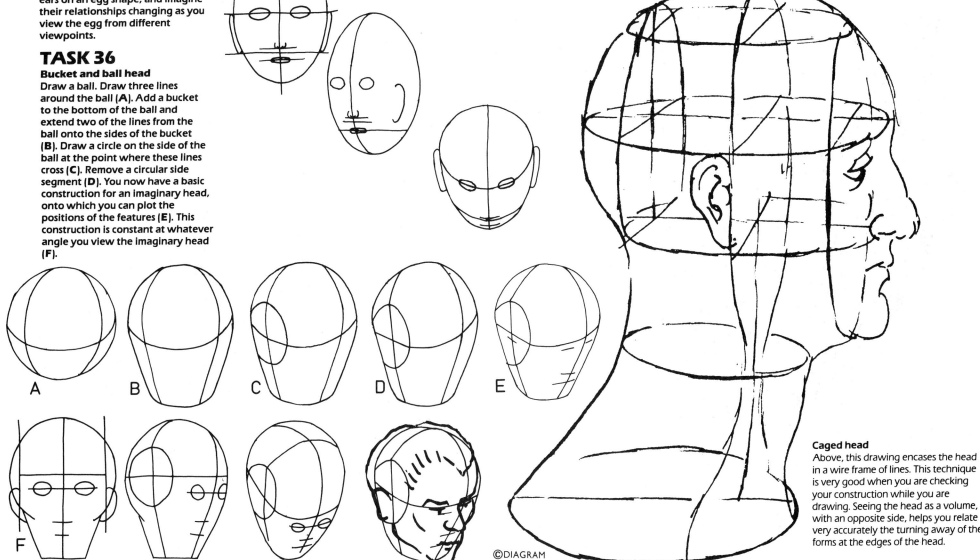

A B C D E

F

©DIAGRAM

Caged head

Above, this drawing encases the head in a wire frame of lines. This technique is very good when you are checking your construction while you are drawing. Seeing the head as a volume, with an opposite side, helps you relate very accurately the turning away of the forms at the edges of the head.

It is always helpful to have some knowledge of the inner structure of the forms you are studying. This knowledge of what is happening on the inside helps explain what you see on the outside. The surface qualities of youthful or aged faces sometimes distracts from the inner structure. Always remember that these surfaces have beneath them different substances which produce different kinds of shapes. Soft fatty tissue, tight muscular features, or hard bone parts all combine to add variety to the surface.

The skull
Right, front, side, top and three-quarter view of the skull. Pencil drawings by Michael, aged 16. If possible, try to do still-life studies of a skull. Failing access to a real skull, do some studies from an anatomy atlas.

Dürer's mother
Left, this study by Albrecht Dürer beautifully describes the soft wrinkled forehead, the drawn hard cheekbones, and the muscular sinews of the neck. Try to study heads with strong structural features such as these to help your understanding of human anatomy.

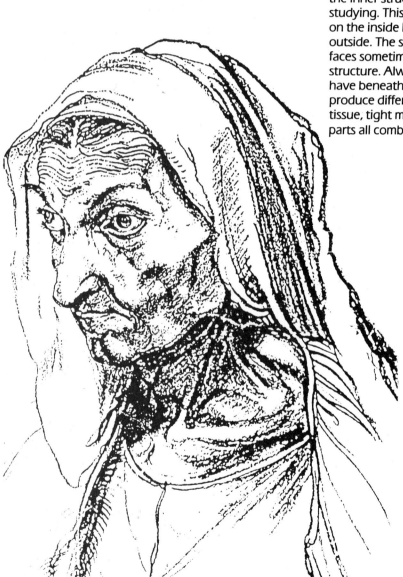

TASK 37
Aging
Draw an old person, if possible directly from a study of someone sitting comfortably in front of you. If this is not possible, then try to do studies from photographs.

TASK 38
Surface clues
Wherever possible on newspaper or magazine photographs fill in on the head those areas where the inner bone is close to the surface. Choose those parts of the skull where cheekbones, chins and foreheads produce hard parts of the surface.

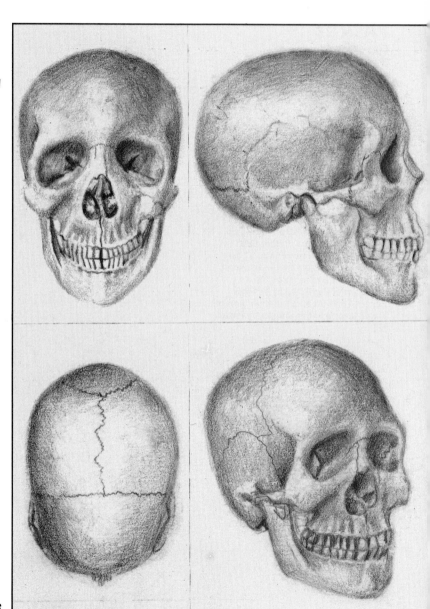

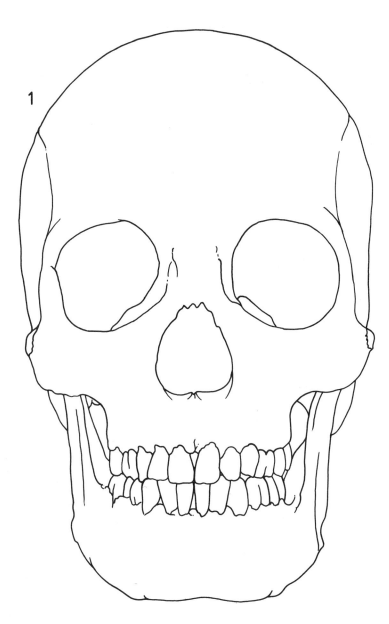

1

TASK 39
Bald beauties
Very often beginners fail to realize that the hair covers a dome-like hard bone. To test your knowledge of the top of the head, draw on to newspaper and magazine photographs the skull's top edge.

TASK 40
X-ray vision
The drawing (below right) by Mark, aged 15, was produced by:
1. First tracing off the skull outline (left).

2. Sitting in front of a mirror and drawing his self-portrait (below left) on a tracing overlay placed over the skull.
3. Then superimposing the two drawings to produce this X-ray version (below).

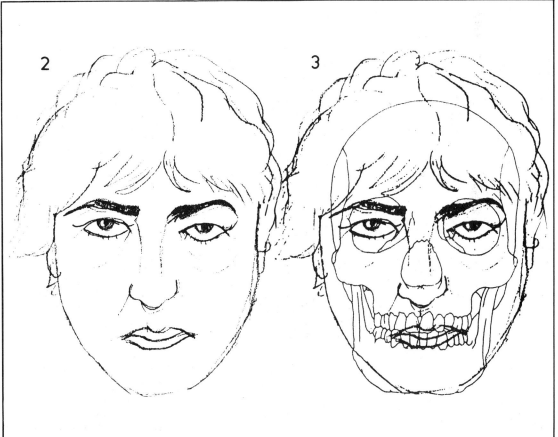

2

3

©DIAGRAM

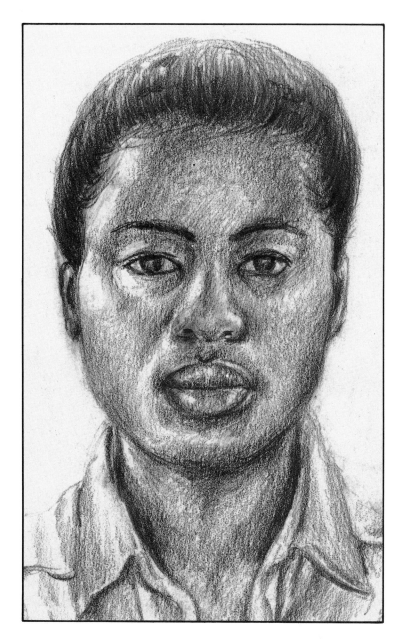

Whatever we look like, our features – eyes, ears, nose and so on – are in the same proportional relationship. A thin face and a fat face both have underlying skulls that determine these proportions. In order to draw heads well, you need to understand this underlying structure and the relationship between the features. You need to draw what is really there, not what you think is there: careful observation and checking is what counts when you are drawing a head. However, it is important that you do not let your understanding of the framework interfere with the feeling and quality of your drawing.

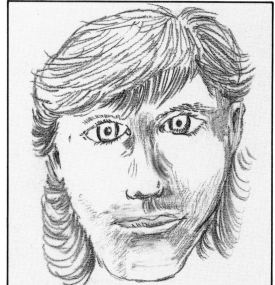 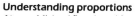

Understanding proportions
Above, Michael first drew his portrait without due attention to the proportions of his face. After reading the instructions (opposite page) he redrew his face with much more concern for the size, positions, and relationships of the parts (above right). Left, Marlene's drawing was achieved by very close attention to the proportions and forms of her face.

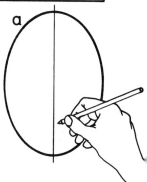

a

TASK 41
Measuring yourself
This exercise will help you to discover the proportions of your face. First draw an oval to represent your face, and divide it in half with a vertical line (a). Use a pencil to measure the distance from the base of your chin to your eye (b). Place a hand on the top of your head to establish the top of your skull, and measure the distance from your hand to your eye (c). If you plot these distances to scale on your oval, you will find that you have drawn your eye halfway up the center line (d). If you continue to work out the relationship between your features, you will find the following: measuring up from your chin, your nose is a quarter of the way up the center line (e); measuring down from your nose, your mouth is at about one-third of the distance between your nose and chin (f); the width of your eye is equal to the distance that your eyes are apart (g); the tops of your eyes and ears align and the bottom of your ears align with the space between your nose and top lip (h).

TASK 42
Construct the ideal face
Applying the method of construction for the proportions, place tracing paper over your Task 2 (your self-portrait) and measure the relationships on your drawing with the actual facts you have just discovered about your face.

TASK 43
Your own self-portrait
Sit in front of a mirror, place tracing paper over the structure grid, (right), and carefully draw your features, locating them along the guidelines. Try to record the small details of your face, using the grid only as a guide to position.

TASK 44
Another person's portrait
Placing the tracing paper over the the grid (right) draw a portrait of a friend or copy a photograph to these proportions.

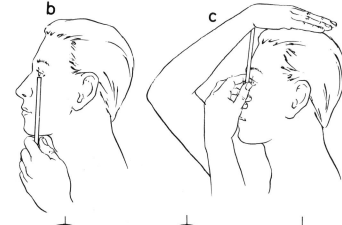

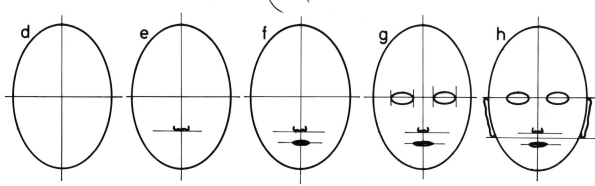

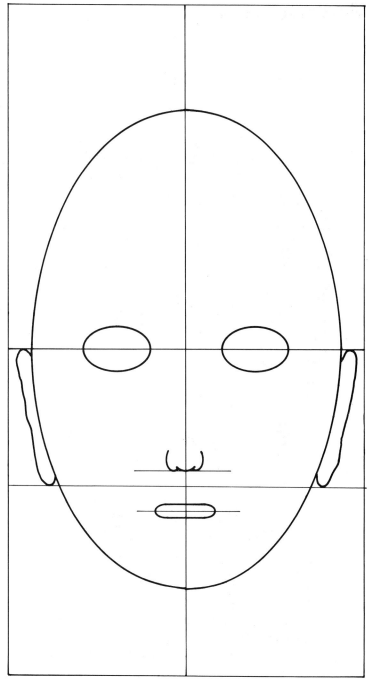

Studying the bumps and hollows of the face helps you to see the elements of the eyes, nose and lips. These fleshy parts have rounded shapes which are useful to keep in mind when drawing their position on the head. Eyes are spheres set like an egg, in a cup, into two encasing eyelids.

Noses are tube-like forms set on a sphere – a sort of upside down ice-cream cone. Lips are folded, overlapping forms which, when the mouth is closed, interlock.

TASK 45
Draw one eye
Sit close to a mirror with the light fully from the front and above your head. Do a series of studies of your eye in which you watch carefully the edges of the lids. On some drawings you can apply the surface tracking lines to check your understanding of the forms.

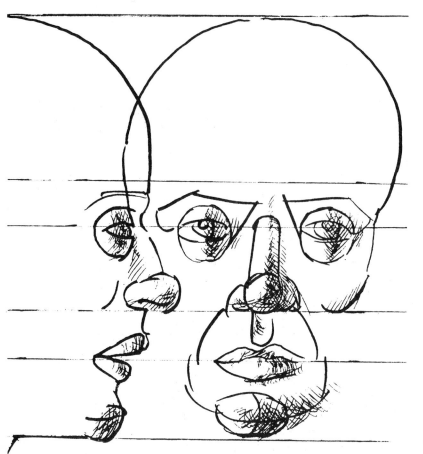

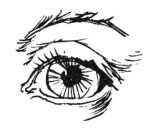

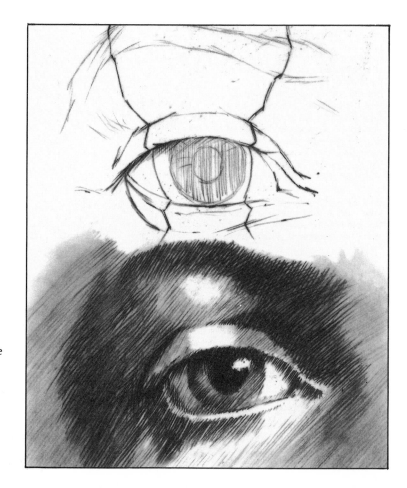

The eye
Whatever it may appear to look like when studying a face, an eyeball is a sphere. The lower and upper eyelids have an edge that catches the light or causes thin shadows on the eye. These edges help to give shape to the eye.

TASK 46

Draw your nose

Using gray paper, black and white chalks, and strong lighting on your face, do a series of drawings of your nose, building up the plan with dark areas and highlights. Notice how when you view the nose straight on you must work up to the light area of the ridge to produce a protruding plane which ends at the tip of the nose

The nose

Below, the top section of a nose usually shows a hard, sharp edge – the section which supports spectacles. The lower section spreads out in three spheres to form an overhanging horizontal triangular plane above the upper lip.

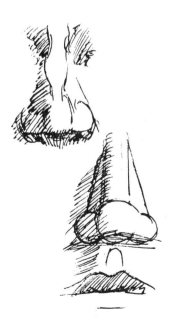

TASK 47

Draw a nose

Below, by studying a friend, or using the double-mirror technique on page 53, build up tonal drawings of the nose from a variety of views.

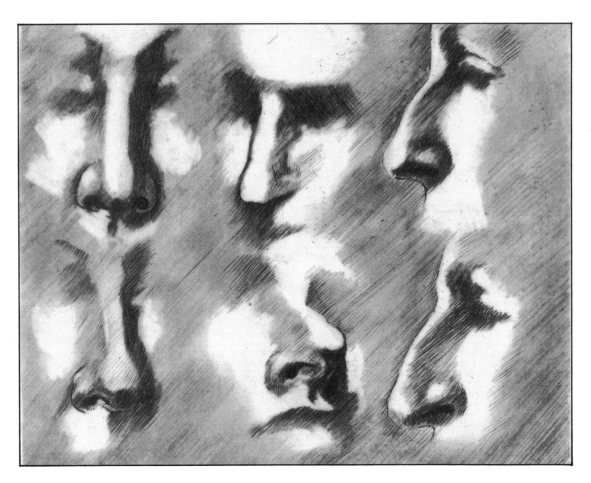

TASK 48

Draw lips

Do pencil studies of your lips, or a friend's, or copy from photographs. Carefully record the vertical and horizontal relationships as these give the position of the lips on the face.

The lips

Right, the basic curve of the lips horizontally across the front of the face is very useful as an indicator of the directional tilt of the head. Pay careful attention to an imaginary center line from the base of the nose to the center of the chin.

© DIAGRAM

Architects are trained to see buildings as three-dimensional spaces – boxes fixed to boxes. The volumes of the inside of the building are reflected in the patterns of the outside. Drawing portraits has a similar need of grasping the 'space-filling' properties of a head. Another useful reminder of this aspect is to think of the head as a vase. As the vase revolves or tilts the patterns (the human features) and the handles

(the ears) change relationships one to another. By cross-checking these relationships carefully as you do your studies you will establish the correct angle from which you should view the model, and the correct tilt of the head on the shoulders.

Elevations
Below, the four drawings are considered as if we were studying a vase. The front, three-quarter view, side and back (opposite left) are all drawn to the same scale and on the same eye level. Note that the elements are all parallel to one another across the four drawings.

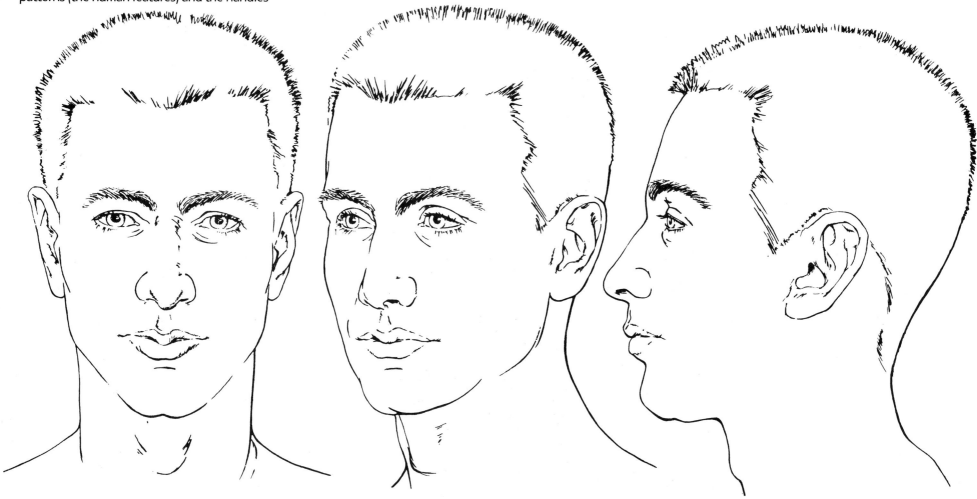

TASK 49
Front/side
Copy these drawings by eye. Do not trace them. Then, using photographic references of other heads, or observations of your own or a friend's head, add the same hairstyle to all four views. Watch the edges of the hair growth on the brow and sides of the first three views.

TASK 50
Side/back
Draw the three-quarter front view, the second drawing, by eye, and do not trace it from the book. Find a good photograph of a pair of spectacles, or obtain a real pair. Draw these on to the head. Do not invent a pair of spectacles.

TASK 51
Back
This Task requires the help of a friend. If you have already drawn the front view of a friend, now draw the back view exactly the same size as the first drawing on these pages.

TASK 52
Tilt
Again ask your friend to pose for you. This time with the head tilted slightly away and to one side. This pose can make the neck ache, so do quick studies from this view.

Tilt
Drawings from life are very rarely seen directly front or side on. The artist usually has a view which includes some small part of adjacent sides. When constructing the drawing always try to see 'across and around' the head to similar elements at the other side.

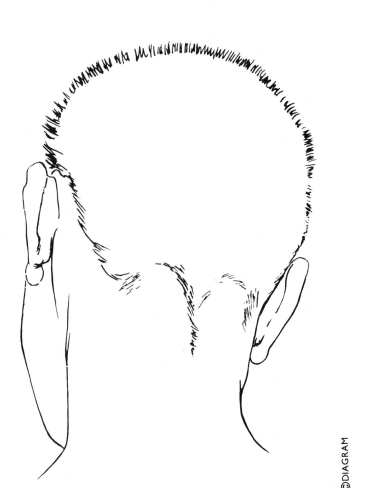

The surfaces of a human head have a variety of qualities. Smooth, as with a new baby, or worn and wrinkled, as on an aging person. Sometimes they are dull absorbent surfaces, or reflective glossy surfaces. Hairstyles are usually the most characteristic feature of a person.

When studying surface detail always retain the memory that it is set on the solid spherical form of the head.

Hair
Right, wild, fuzzy, bush-like growth to smooth, glossy head-clinging forms. The variety of styles and textures is infinite.

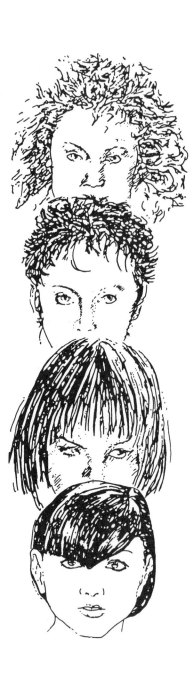

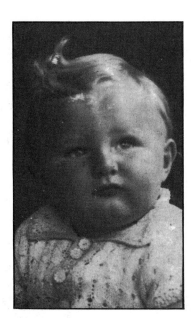 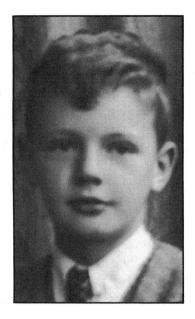 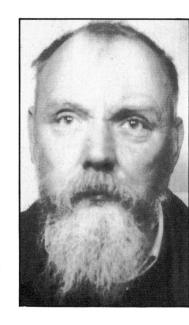

Aging
Above left to right, the author aged one year, ten years, twenty years and fifty years. Notice how hair and skin change with age.

TASK 53
Skin textures
Your skin texture varies with age and from one part of the body to another. To examine the subtle variety of texture do two small drawings of your skin, both actual size. Draw an area of the back of your left hand, then an area of the palm of the same hand.

TASK 54
Aging
Copy a photograph taken of yourself at an earlier age, and one taken recently. Compare the two, noticing changes in shape and texture.

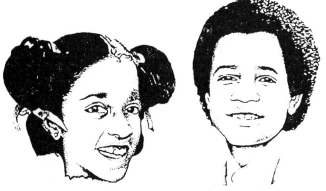

Personality
Left, drawings that retain the personality of the subject. The hair and skin qualities help us to 'feel' the surfaces of the head.

TASK 55
Hairstyles
Collect examples from magazines and newspapers of different hair-styles.

TASK 56
Hair lines
Copy, do not trace, the heads (below) and add eyebrows, mustaches, beards and hair to your drawings. Do not invent the hairstyle, find a strong style in a photograph and transfer that to the heads.

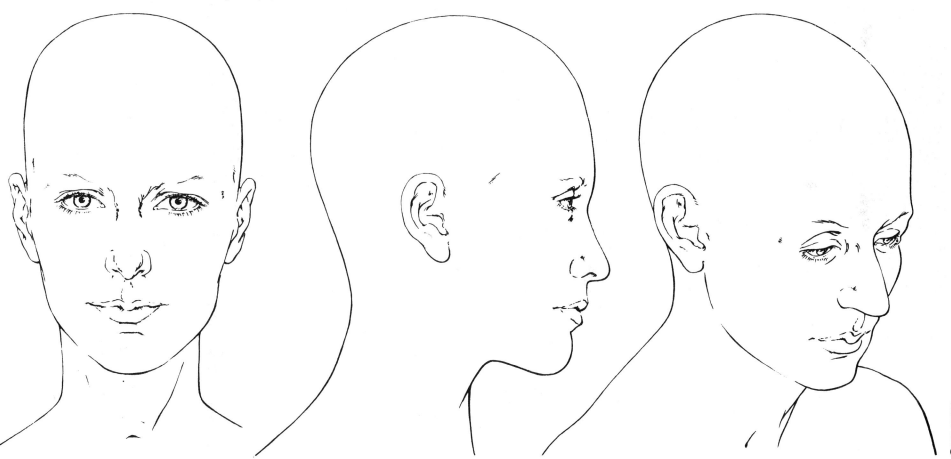

©DIAGRAM

Successful portraits
Most successful portraits are produced when you take care to record accurately what you see. Three important points are to check proportions; to describe the bumps and hollows; to keep the volume of the head in your mind's eye.

TASK 57
Proportional checking
Check each drawing for basic faults of proportion. Are the eyes midway between the top and the bottom of the face? Do the sizes of the features relate to one another at the correct scale?

TASK 58
Shadows and tones
Check each drawing for its inner structure. Could the skull fit into your outline of the head? Does the drawing show hard and soft parts of the inner structure?

TASK 59
Surface texture
Check each drawing for its ability to describe surface textures. Have you in your early Task 2 drawn the eyes so that it is possible to guess at their color? Do your drawings of hair look like the hair you studied?

TASK 60
Mapping surfaces
Do your drawings reveal the bumps and hollows of a face? Do the eyes look round and set into the head? Does the nose stick out from the face?

Common faults of beginners:
1 Features too large for size of head
2 Face appears flat with no description of form.
3 Nose seen side-on when the head is from three-quarter front.
4 Eye seen front-on when drawing side view of the head.
5 Top of head too small for face.
6 Ear in wrong position.
At this point you will have done over fifty Tasks and it will be useful to review all the work from the point of view of understanding what you see when you draw. When checking your faults, do not correct your drawings. retain them in their original form, and if you feel inclined, re-draw them correcting the errors.

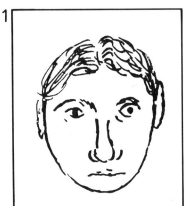

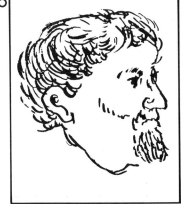
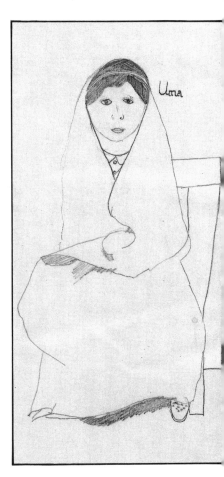

Observing detail
Right, portrait of Uma by her school friend Helen, aged 12 years.

In this chapter we look at how the choice of tool affects the type of mark you make. Some tools are more suitable than others for producing the results you have in mind. Pencils are the best and easiest to achieve a wide variety of line qualities. Brushes, pens and technical drawing instruments all require some degree of confidence and experience. Commercial writing tools like ball-point pens and felt-tipped pens do not allow you to make corrections, so your confidence in the marks you make must be such that you can build on erroneous marks without damaging your ultimate effects.

Never be afraid of the drawing implement. You are the master of the tool. Work slowly and carefully when beginning with an unfamiliar tool. Remember it is not what you draw with, or how you draw, that matters, but what you say in your drawing. The surface of your drawing must also be considered – rough papers are not good for achieving fine details, and smooth papers are hard to work with for tonal drawings.

- The first two pages, 36 and 37, offer an opportunity to look at drawings simply as marks on a page. You explore their graphic quality.
- Pages 38 and 39 set you working only in tones, while pages 40 and 41 deal with restricting your work to expressing form and color in lines.
- Pages 42 and 43 show examples of artists enjoying the textured surface of their drawings.
- Finally, page 44 brings you back to drawings where your main concern is to explore the graphic qualities of your work.

The twenty Tasks in the chapter teach you to master the tools. Experience is the best teacher.

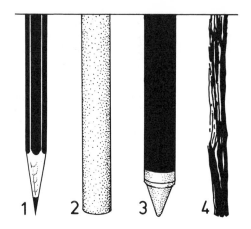

Each different drawing implement makes different types of marks on the paper. Some provide opportunities for grays and gradual tones (pencils and chalks), others are very difficult to correct (brushes and pens). There is no correct tool to use. The best tool is the one you feel confident with. Some tools require you to consider the surface you are using. Pencils are not good on smooth glossy paper. Chalks require a soft surface for the fine particles to hold. Brushes are very bad on thin paper or tracing paper as the water causes the surface to buckle. Pens and technical drawing instruments should be used only on very smooth-coated, glossy paper, or on thin plastic. Pens on rough paper cause frustration and error.

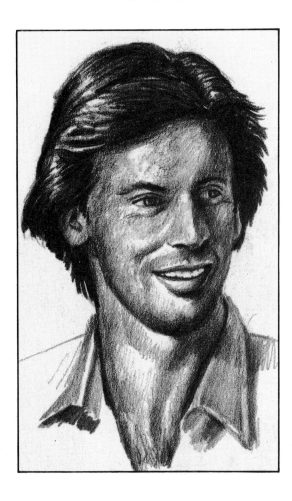

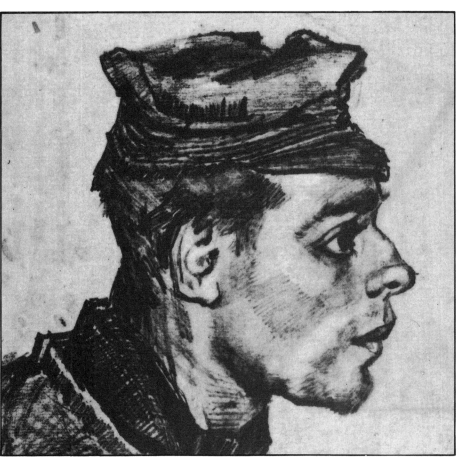

Dry-medium tools
1. Pencils are the most popular and most accessible.
2. Chalks require fixing with a spray after completion of the drawing to prevent later smudging.
3. Crayons, the waxed variety, are hard to use as errors cannot be corrected easily and the points of crayons seldom stay sharp.
4. Charcoal offers a wide range of tones, but must be 'fixed' when completed to avoid smudging.

Pencil drawing
Far left, the drawing, reproduced actual size, is a copy by Lee from a photograph. He was able to achieve a close copy of the tones by varying the weight of the line.

Charcoal drawing
Left, Vincent Van Gogh's study of a peasant. It was most probably drawn on rough-surface paper.

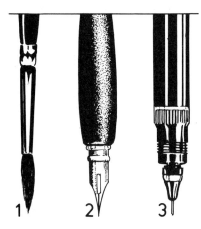

1 2 3

Seeing reality in its tones, or different grades of shading, is the easiest part of drawing. Natural light creates whites, grays and darks. Seeing drawing in terms of lights and darks requires you to hold two images in your mind at the same time. The first is the description of reality, the second the patterns of tones on the page. Artists enjoy playing visual games with the shapes, colors and tones of their drawings. They bring out in a particular view two-dimensional patterns that are not present in the world they observe.

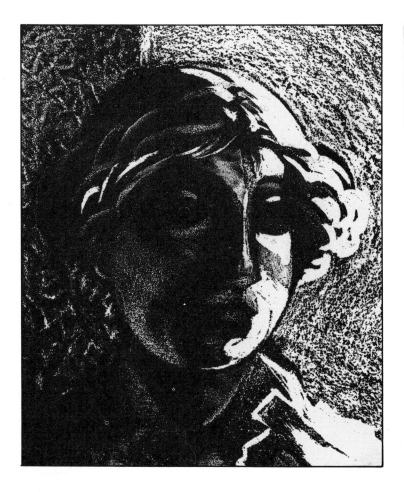

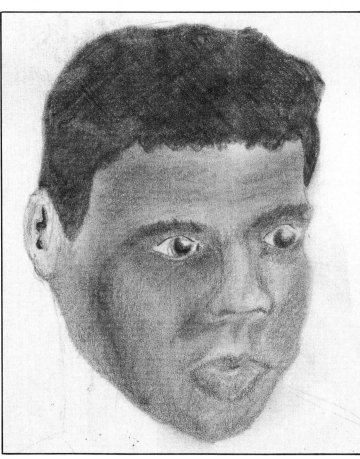

TASK 65
Flat tones
Do a copy of the pencil rendered tones above, and check your copy by folding over the edge and placing it on the page, alongside a similar tone.

Color
Left, a drawing by a 16-year-old boy. He took care to record the color of the eyes and skin.

Light and shade
Far left, exaggerated lighting effects can produce a drawing with high dramatic qualities. This head is lit from one source.

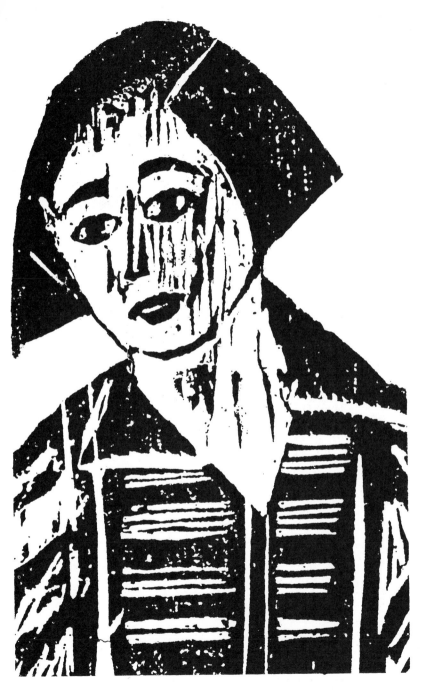

TASK 66
Tonal match

Copy a head from a photograph in a magazine, and try to record the tonal values as carefully as you can. Then fold the photograph vertically in half and hold it close to similar areas of your drawing. See how your tonal values match those on the photograph.

TASK 67
Out of darkness

Using a gray paper, work with white and black chalks to build up the effects of lighting on a face. Use either a photograph with strong lighting, or do a self-portrait posing with a direct single lighting source as in Task 11.

TASK 68
Color

Select a color photograph or a reproduction of a painting and redraw it in black and white. Keep the related color values in balance with the tonal values of your black and white drawing.

Pattern
Far left, this is not a drawing. It is a print of a linocut. The artist drew with a sharp gouge, cutting away the white areas. This method requires you to think of your drawing in terms of strong patterns.

Graphic texture
Right, an example of the texture of the drawing tool marks. This study utilizes the hand-repeated shading lines to build up areas of tone.

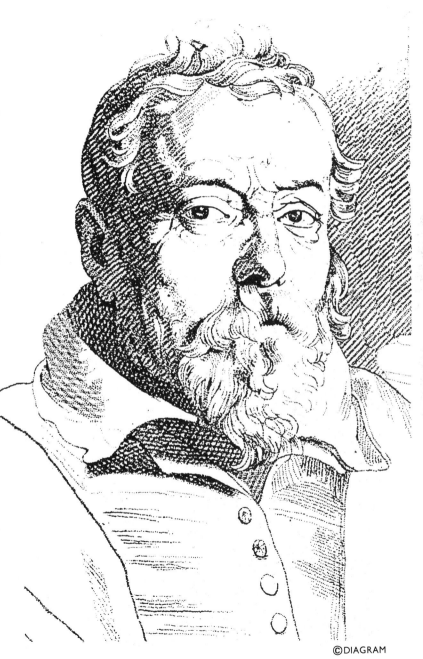

©DIAGRAM

Lines enclose areas called shapes, but they do not exist in nature. They are the edges of forms or changes in texture, or tones of colors. When you draw in line, you reinvent reality. You use a language of conventions. It is by the standard of their line drawing that you can test the quality of an accomplished artist.

When you work in line you are using a sort of shorthand for reality. Beginners should feel confident that they can weed out of the subject all the details not needed when presenting their view of the subject.

TASK 69
Collect line drawings
Wherever heads are drawn, in cartoons, comics, newspapers, magazines, books, posters and emblems, collect and copy them into a scrapbook of ideas.

TASK 70
Convert tone to line
Select any one of your earlier drawings and produce a new version of it, converting the tones in the drawing to a series of outlines.

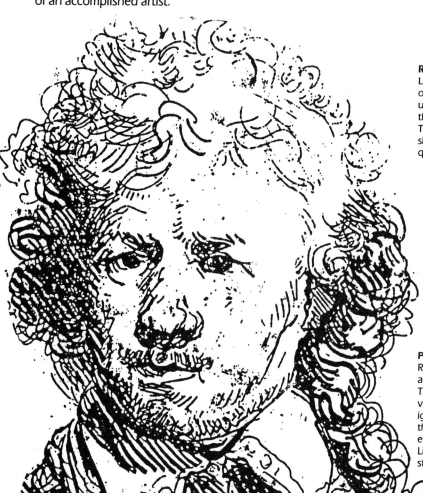

Rembrandt self-portrait
Left, this is not a drawing – it is a print of an etching. The artist drew himself using a fine sharp needle, scratching the lines on to a waxed metal plate. This illustration is an enlargement to show the confident 'handwriting quality' of working in line.

Pen sketching
Right, this drawing by Marcel Janco is anatomically incorrect. All the previous Tasks about proportion, structure, volume, texture and tone have been ignored in this drawing. Nevertheless, this use of line captures the attentive, energetic character very successfully. Line drawings are good for quick studies.

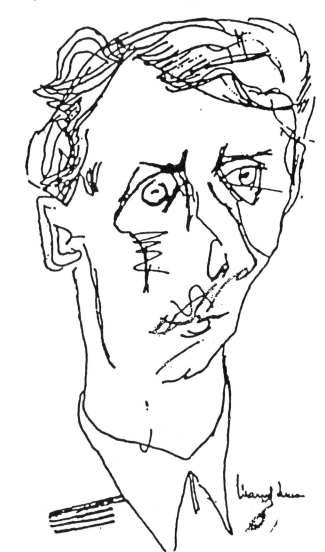

TASK 71
Speed of line
Do a series of quick line drawings from newspaper photographs of a head. Do not worry about accuracy. Work enthusiastically to draw the form and texture, using the minimum number of lines.

TASK 72
Only in line
Another version of tonal drawings. Using your earlier tonal drawings in Tasks 66 and 67, do a copy building up the same effects with an interwoven net of cross-hatched lines.

Precision line drawing
Left, this drawing by Gris is a very careful, very patient, line study. The artist built up the structure in a light line drawing which he then worked up with a single specific line, taking care that he considered all the forms and shapes accurately.

Knitted lines
Above right, a student study greatly reduced to show the tonal effects. Line drawing has traditionally been used to describe tones by building up overlays of knitted parallel lines. These areas, which appear to the eye as tones, are actually thin weavings of lines. Below right, a section actual size.

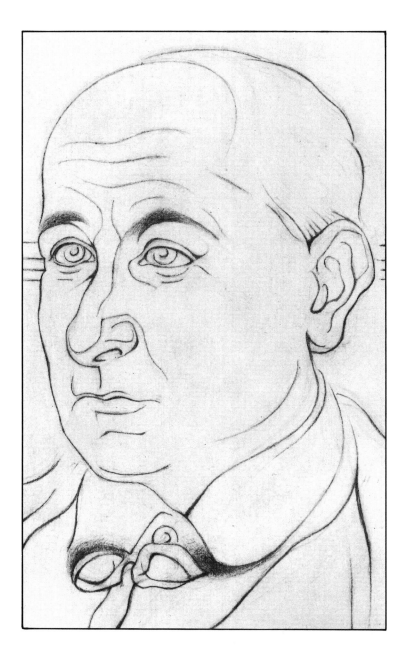

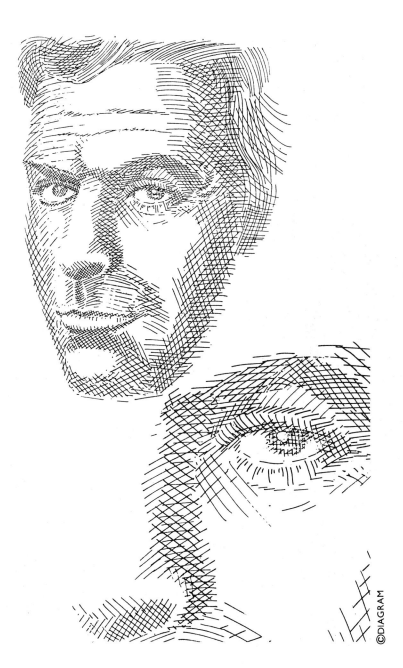

©DIAGRAM

The surface textures of a drawing are not necessarily similar to those on the subject. The effects of the paper's smoothness or roughness on a drawing can be attractive as qualities of the drawing, especially if it is to be used for reproduction.

When exploring textural surface effects you must always remember that it is the content of the drawing and not its effects that are the most important.

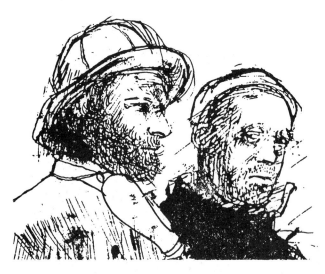

Seamen
Above, these night fishermen were drawn with pen and ink on thin paper – in the open, on a rolling sea, in the rain. The ink, the paper, the fatigue all combine to give the result a roughness and directness suitable for the subject.

Granny
Right, drawing by Anne, aged 11. This is reproduced here smaller than the original, which combined the coarse brown paper surface with the soft lead pencil marks to give the drawing a warm and sympathetic feel.

Four tasks to test surface qualities
Draw each picture 3 in x 3 in (7.6cm). Use one of your earlier drawings for reference, or copy a new subject from a photograph or model.

TASK 73
Pencil grades
Collect pencils of varying grades. The B's are soft and the H's hard. Do a drawing with a 3B or softer, and one with a 3H or harder. Compare the differences of quality.

TASK 74
Surface qualities
Repeat the drawing in Task 73 using a 3B or softer and do two drawings: one on very rough surfaced paper, like watercolor papers or 'sugar' paper; the other on glossy, smooth paper. Compare all four drawings.

TASK 75
Absorption
Repeat the drawing with inks, brushes and pens on absorbent paper. A piece of blank newspaper area is good for this exercise. Repeat on glossy paper.

TASK 76
Resistance
Repeat the drawing using a brush and ink on clear plastic. Collect all seven examples of paper, and stick them on a sheet, captioning them with the tool and materials.

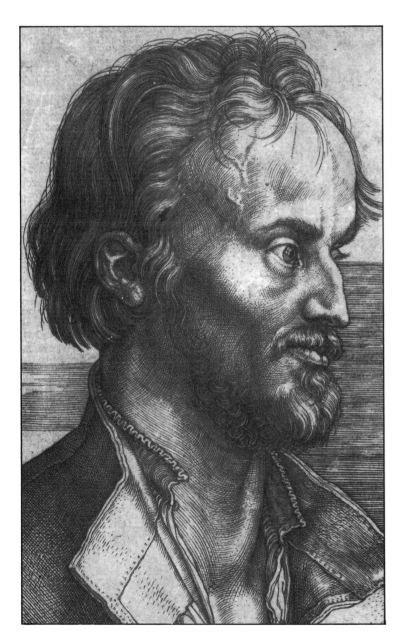

Study by Dürer
Left, this is not a drawing. It is a print of an engraving. The sharp point of the engraving tool cuts very fine lines so that the resulting print is very delicate in its detail. This is a very difficult medium to master.

Che
Right, this was done with Indian ink, an old brush, and on very thin glossy clear plastic (the type used to wrap food). The surface resistance of the material and the nervous energy of the old brush marks created irregular shapes. When the ink was dry, the drawing was crumpled up into a tiny ball, which caused the ink to peel.

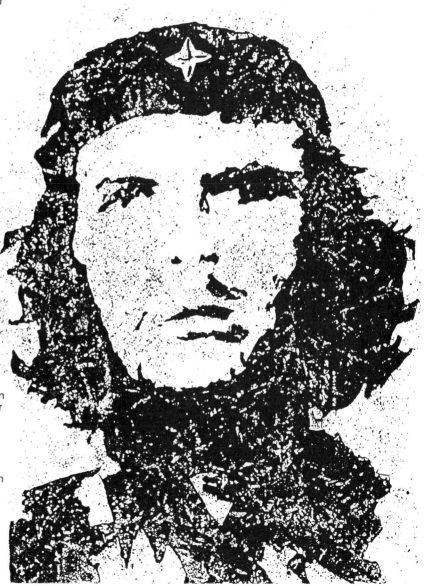

©DIAGRAM

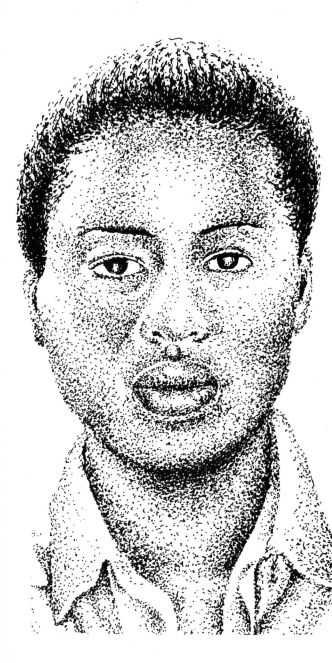

The technique
This chapter was not about drawing, it was about how drawings are produced – the technique of drawing. Never be fooled into believing that technique is preferable to seeing or understanding. Nevertheless, you can achieve wonderful results by exploring the possibilities of using the marks made by drawing tools.

Marlene
Left, this drawing was produced by Marlene placing a thin sheet of plastic over her earlier pencil drawing on page 26, and building up the tones to represent the lighting effects of the earlier drawing. She used a technical drawing instrument that produces a regular dot or line. The drawing (right), reduced, was achieved by sketching in ink and brush on the first drawing.

TASK 77

Recording the technique
Mark in the corner in a soft pencil the method by which you have drawn the previous 76 tasks. If most are in pencil, consider using other tools, and now you have a little more experience, even re-doing tasks in pen, brush or technical drawing tools.

TASK 78

Convert a previous drawing
Convert a previous drawing to a new and unfamiliar drawing with a technical tool.

TASK 79

Convert to pen dots
Using Task 2 (your self-portrait), redraw, using a dot-to-dot technique like Marlene's drawing on this page.

TASK 80

Convert to your least-happy tool
Overcome your fears of unfamiliar tools by copying a photograph or earlier drawing with a tool you feel uncomfortable with. This is surprisingly rewarding.

CONSIDERING DESIGN

This chapter is concerned with seeing the drawing as independent of the subject, and how to enjoy the graphic qualities of a portrait drawing. There are twenty Tasks to help you explore the style of drawing, the view of the subject in relation to the picture's shape, the composition of the picture, and the way we bring pre-judgements of what a face should look like to the study.

- The first two pages, 46 and 47, compare the different ways artists make marks on the paper – their handwriting.
- Pages 48 and 48 suggest that by selecting a different and sometimes difficult view your drawing can have a new visual interest.
- The aspect least considered when beginning a portrait is its position on the page. Pages 50 and 51 look at the composition of drawings. By exploring new ways to frame your work you bring new dynamics to your work.

- Pages 52 and 53 move away from the subject and consider our pre-judgements of what we think the face is like. These pages contain a Task – drawing yourself from the side – which, if drawn with accuracy, can be of great help when doing later self-portraits from the front.
- Finally, page 54 invites you to explore new pattern-making ways of producing a drawing.

Handwriting
One unconscious influence working on your drawing is your own handwriting style. It is the natural way you make marks on the paper. Never let this be a conscious part of the drawing – let it be the result of the tool, the surface, the circumstances and the subject. Doing what comes naturally is always best.

TASK 81
Copying
Try to obtain a copy from a book of an original drawing reproduced the same size. Working with the same tools as the original artist, try to copy his work, studying how he produced the drawing.

TASK 82
Imitating
Redraw Task 2 (your self-portrait), using the style of an artist you admire.

TASK 83
Handicap
Redraw Task 2 (your self-portrait), using the hand other than the one normally used for drawing.

Parallel lines
Left, a detail from a 19th-century drawing. Thicks and thins create the optical effect of lights and darks.

Agitated lines
Right, Vincent Van Gogh's drawing reveals his nervous state as he 'pecks' out the tones on the background and face.

TASK 84
Styling
This is great fun. Redraw Task 2 (your self-portrait) or others in as wide a variety of styles as you can invent. Explore techniques and ways of looking at the drawing – experiment. Do not be afraid of failures. Successful drawings are well worth all the failures.

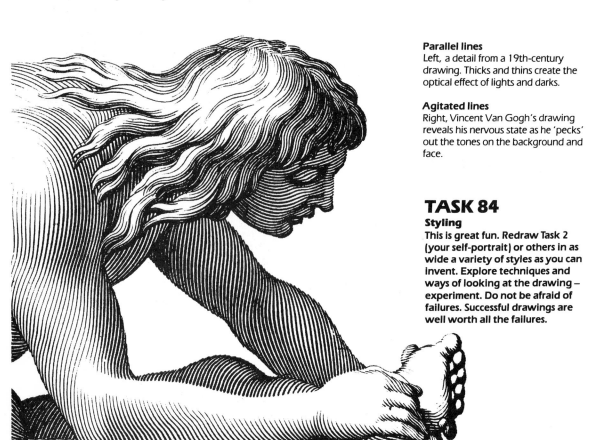

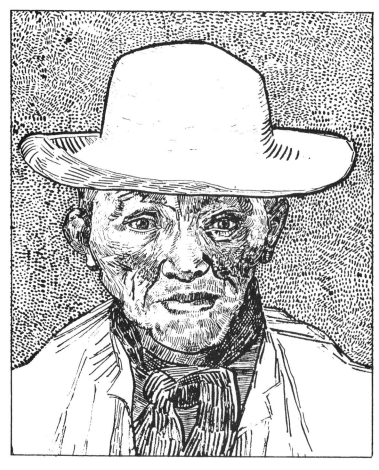

Drawing unnaturally
Below, Graham's self-portrait on page 53 was drawn with his right hand, the one used normally for writing. This is a drawing with his left hand. Compare the difference in line quality.

Exploration
Right, five drawings made from the photograph using a variety of styles and techniques. Can you guess how they were drawn?

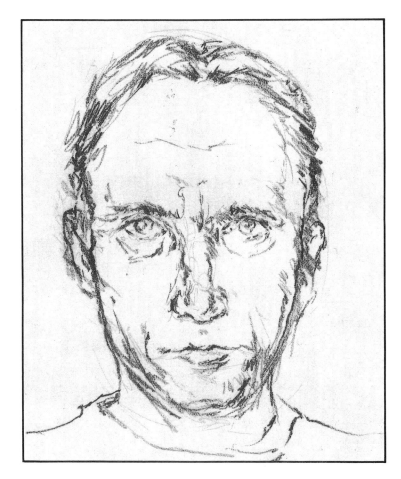

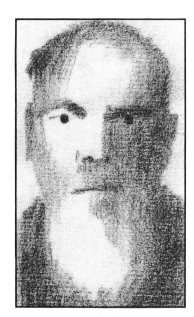

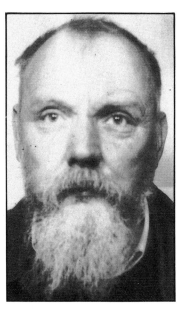

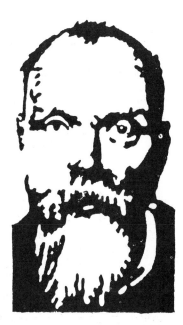

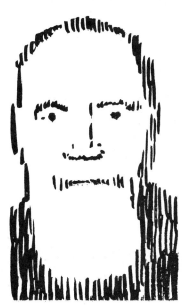

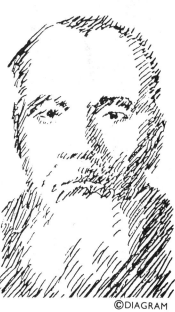

©DIAGRAM

48 **Your view**

When you are beginning your drawing you should take into account your eye level. This is the imaginary horizon opposite your eyes when you view the subject. The head, when viewed from above, is longer than it is wide; when viewing it from below, the ear will appear lower on your drawing than the model's eyes.

TASK 85
Relationships
Draw a person wearing spectacles. Select two views, one from above and one from below. Compare the horizontal lines of the spectacles' side frame in your two drawings.

TASK 86
Plan view
Ask a friend to lie down so that you can observe the top of their head. Do a drawing as if you were viewing them from above.

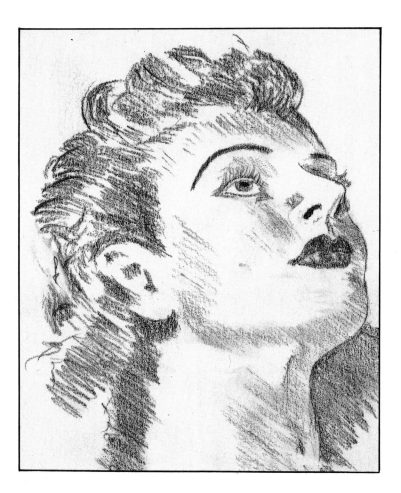

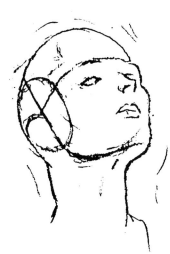

The underview
Above, when beginning a drawing from any unfamiliar viewpoint, first sketch out the basic elements using the bucket and ball technique from page 23. This abstract construct should not appear in your final drawing (left).

Thick head
Right, the human brain is deeper from front to back than it is wide. This ratio is seldom remembered by beginners when viewing the head from an unusual angle.

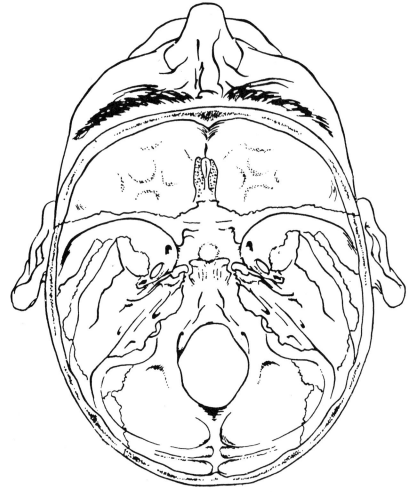

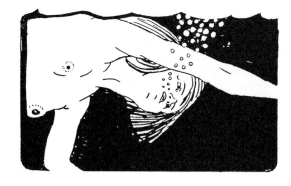

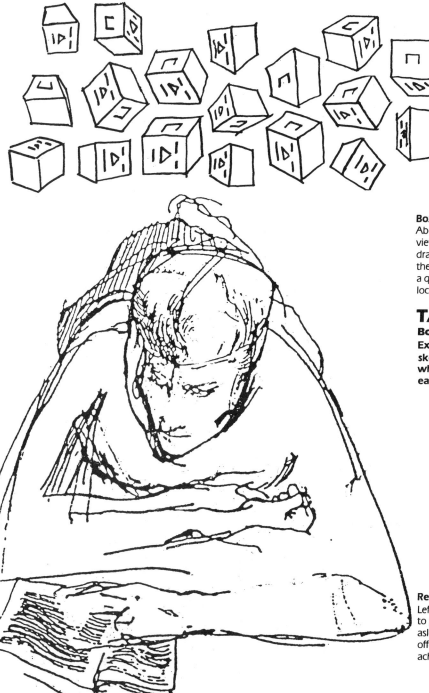

Box-like heads
Above, when considering unusual views, it is advisable to practice by drawing box-like heads. Although these seem childish, artists use these as a quick method for checking the location of the ear to the features.

TASK 87
Boxed views
Explore the variety of views by sketching box-like heads onto which you draw the features and ear.

Changing view
Above, this drawing of a swimmer was first drawn from a study of a model who briefly stood with her arm up and was sketched from a low eye level. The studies were used to reproduce a drawing which was then turned sideways and the sea and bubbles added. Turn the page sideways to see the artist's original view of the model.

TASK 88
Under and over
Collect views in magazines of head views from above or below.

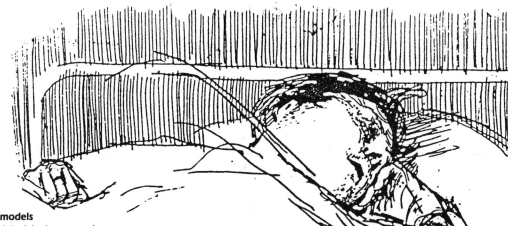

Resting models
Left and right, it is always good to practice sketching someone who is asleep or resting. Sit in a position which offers you a view not normally achieved from a posing figure.

©DIAGRAM

50 Composition

The position of a drawing on the mounting paper has an influential effect on its appeal. Poor drawings cannot be improved by framing, but those of medium quality, and good drawings, are enhanced by virtue of their position within the rectangle.

TASK 89
Adjustable frame
Make yourself two L shaped frames using card, each side being approximately 12 inches long. Place these over a drawing and move them to form a rectangle whose composition you find attractive.

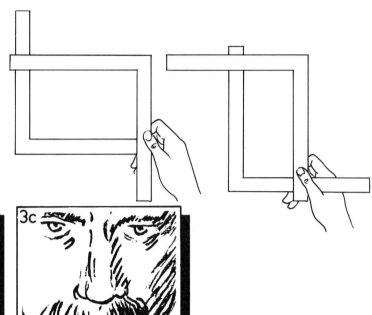

1a

2a

3a

3c

1b

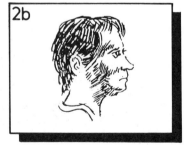

2b

3b

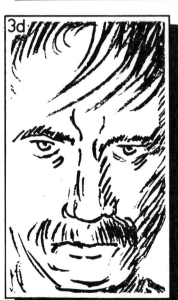

3d

3e

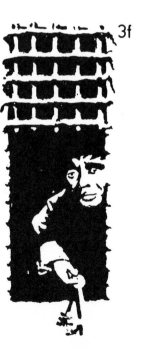

3f

There are three factors influencing the drawing's composition:
1 The subject's spacial relationship to the picture plane.
1a parallel, **1b** angled.
2 Its size within the drawing area.
2a small, **2b** large.

3 Its position in the frame.
3a and **3b** same size but different positions, **3c** and **3d** same size but different frame sizes, **3e** incomplete, **3f** protruding and using the picture frame as part of the drawing shapes.

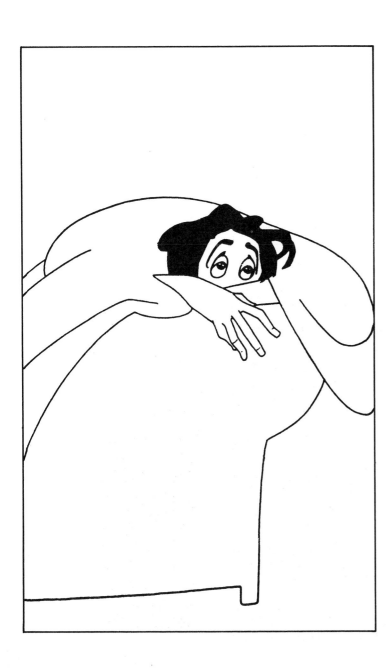

Dynamics
Left, the position of the head in the drawing is enormously enhanced by the dark area of the hair, and the emptiness of the rest of the page. Your attention is directed immediately to the subject's eyes.

TASK 90
Size
Do two drawings, one of which could be a redrawn version of Task 2 (your self portrait). Place both drawings in the center of 2 sheets of paper, approximately 12 inches by 18 inches in size. The first drawing should be positioned 3 inches high, the second approximately 10 inches high. Pin both on the notice board and compare the effects of the surrounding white space.

Space
As well as horizontal and vertical space — the compositional elements — a drawing can use the inner space, moving out from the page like the drawing (right) and the one on page 7. This is not easily achieved as you are required to describe foreshortened forms convincingly.

TASK 91
Cropping
Collect photographs from magazines and cut away their sides until you have an interesting composition.

TASK 92
Composition
Collect postcards and printed examples of famous artists' works and consider their compositional solutions. Degas, the 19th-century painter, had very many exciting figure studies for his compositions.

©DIAGRAM

Beginners always express the fear 'I can see it, but I cannot draw it.' They instinctively know what a subject looks like, but cannot capture their impressions on paper. This is because much of what we see we read as generalizations – an impression of reality. The actual world is complex and infinitely variable. Our view of it is transformed into a code of representation.

Visions
Below, 'The man who instructed Mr. Blake in painting in his dreams.' This represents the art teacher of the 19th-century English artist William Blake. No such person existed – Blake dreamed these features. They are an assembly of learned parts – eyes, noses, mouths – remembered bits of his wakeful observations, combined here to represent a fictitious person. We must learn to record our observations and not simply represent them with codes for eyes, noses, mouths, hair and skin. Always draw the particular, never the general.

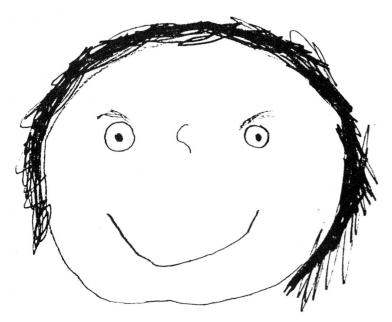

Concepts
Above, a drawing by Zoë, aged 5. It was her first subject study. She knows what she looks like and can recognize herself in photographs. Her drawing, though, does not yet make the connection with concepts and recorded observations. 'This is Zoë' she says. What she is really saying is 'This represents Zoë.'

TASK 93
Memory test 1
Select any picture in this book, then close the book and, without turning back to it, do a simple sketch of it. Now compare your memory of it and the reality.

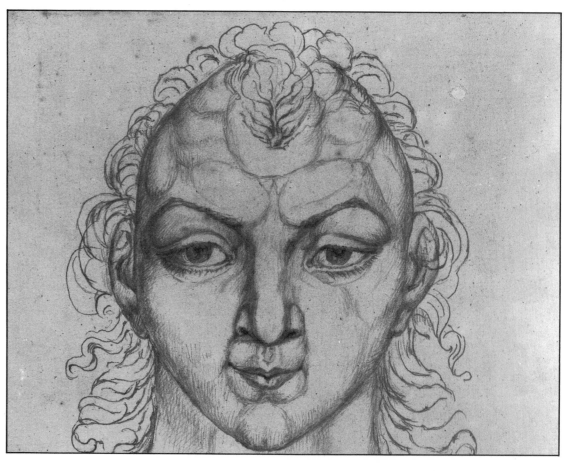

TASK 94
Memory test 2
Select any of your earlier drawings (but not those of yourself) and from memory re-draw the picture. One consequence of this Task is that the second is usually better than the first. The reason for this is that, having previously drawn a subject, it is somehow committed to our memory more permanently than those just casually examined.

TASK 95
Yourself
This is great fun. Redraw Task 2 (your self-portrait) from memory and compare the two drawings.

Side view
Graham drew his front view by looking in the mirror. He then positioned two large mirrors so that he could study his side view by looking in the front mirror at the reflection.

TASK 96
Self side view
Arrange two large mirrors in positions where the view of the side of your head in one mirror receives the reflection in the other. If you produce a successful study, leave your drawing in a conspicuous place for your friends to comment on. They will be very impressed with your ability to see yourself as they see you.

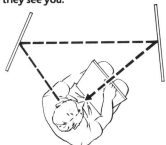

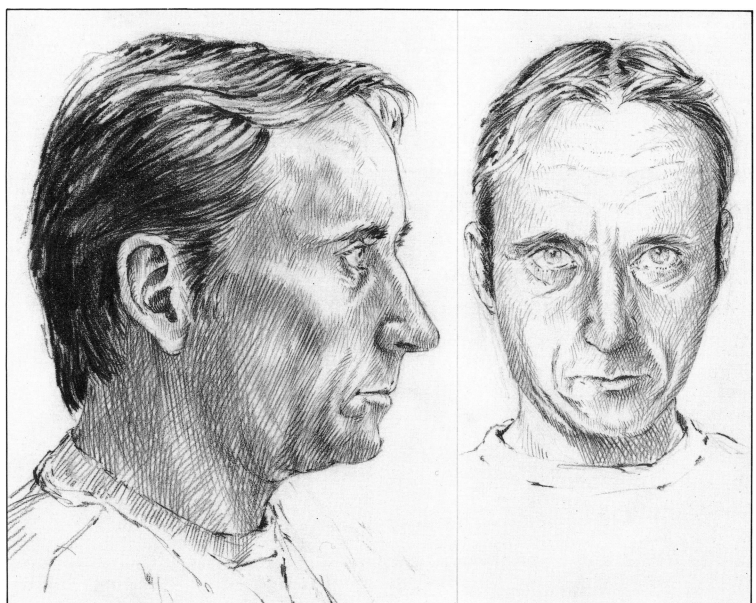

©DIAGRAM

Graphic qualities
The Tasks in this chapter are designed to help you consider the appearance of your drawing – its graphic qualities. Remember that although these topics are visually stimulating, it is the objective of good drawing to portray the solid world on a flat surface.

Below, this drawing is of the same subject as that on page 43. It converts the study into curved, blob-like shapes. The three drawings below right are experiments from page 21.

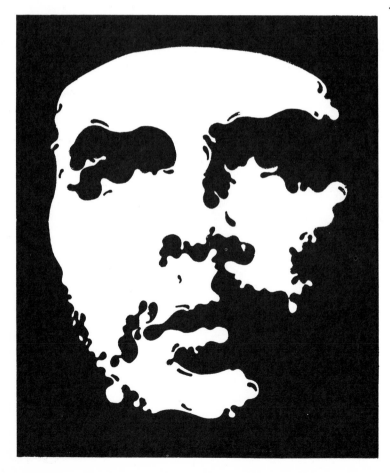

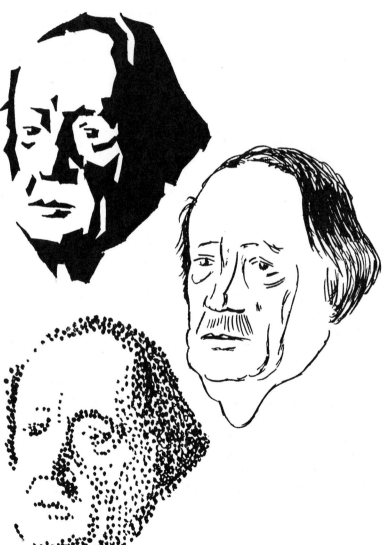

TASK 97
Graphic variety
Collect examples of artists' extreme graphic styles from newspapers and magazines.

TASK 98
Simplification
Place tracing paper over any illustration in this book and convert it to simple patterns.

TASK 99
Pointillist
Convert a drawing to a built-up dot pattern.

TASK 100
Convert your own portrait
Convert your own portrait to a pattern of shapes and, when complete, ask your friends who the drawing is of.

DRAWING WITH THE HEART CHAPTER 5

Drawing with your heart is excellent therapy. Like yoga, chess or sailing, the concentration required is rewarded by the inner peace that success brings. It is never a good idea to take Tasks too seriously. They need an element of play to make them enjoyable. These next twenty Tasks assume you have learned how to draw, and now it's time to 'kick the ball about.' Bounce ideas freely off the wall. Enjoyment is what drawing is about. Express your views of what you see.

- The first two pages, 56 and 57, reassure you with the idea that the hardest part of portraiture – capturing likeness – comes automatically if you follow the earlier advice on drawing.
- Then pages 58 and 59 explore what we consider as the total face, the parts and their relationship to the whole:
- On pages 60 and 61 you can have some fun with Tasks that express the emotions of the subject.
 Try to record the emotional conditions of the person you are drawing – the objective observation.
- On pages 62 and 63 we explore our emotional reactions to the subject we are observing.
- Finally, page 64 gives some good advice – and extracts a promise!

Capturing likeness

Capturing likeness is probably the hardest part of portrait drawing. Do not be discouraged. Look, observe, and seek to understand what you see. Record and reconsider, then re-check and modify your work. The natural qualities of a face will automatically appear. People with a strong personality often reveal this in their face, so select subjects whose appearance helps you in your search for the uniqueness of a face.

Luther
Below left, I have used this example many times to illustrate the uniqueness of portraits. The 16th-century artist, Cranach, was so observant and honest that he recorded for all time the mole on Luther's brow over his left eye.

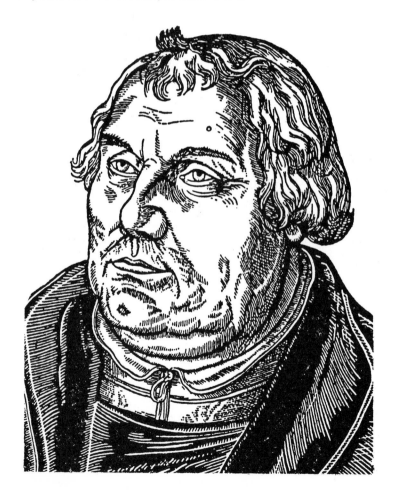

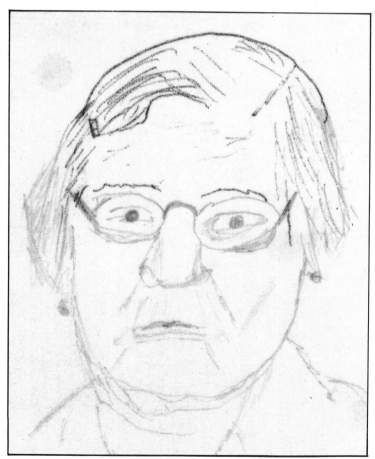

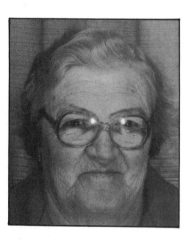

Granny
This is the first-ever observation study by granny, aged 76. As you can see from her photograph, her first attempt captures a little of her features. She is also the model for a study on page 42.

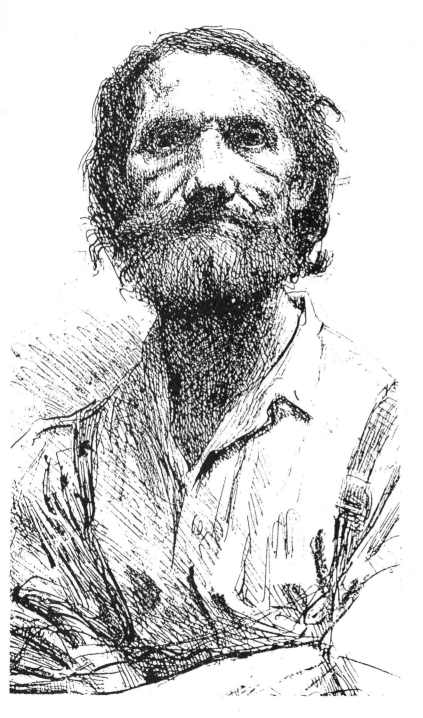

Defiance
Left, the direct stare of the subject in this study is an excellent rendering of his character. He is obviously not a quitter. His lean features describe a hard-working, persistant personality.

Self-portrait
Below, Rembrandt never failed to discover new aspects of his own face. For over thirty years he continued to draw himself. Compare this with his earlier self-portrait on page 40. This example is a copy by a present-day student. You should copy great artists' drawings whenever possible.

TASK 101
Dossier
Make a series of notes about your own features, color of hair, eyes, shape of nose, ears, etc. Compare these to your self-portrait (Task 2).

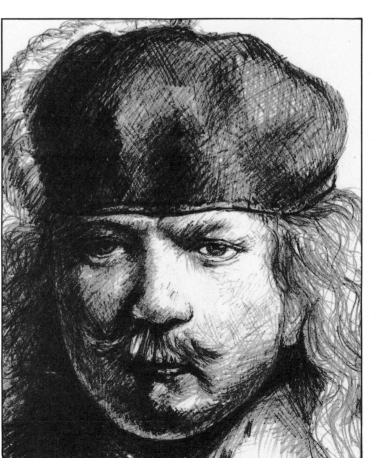

TASK 102
Character study
Draw a person with a strong personality.

TASK 103
Fame
Draw from photos a movie star or pop star, a person everyone recognizes. Then show the drawing to your friends and ask who it is.

TASK 104
The ultimate test
Do a drawing of a friend and show your drawing to others who know the subject and see if they recognize your mutual friend.

58 Photofit

Police use a method of building up a face from individual parts. Superimposed on a selected basic shape are an infinite variety of combinations of eyes, noses, mouths, hair. These seldom resemble the real person. A face is more than the parts.

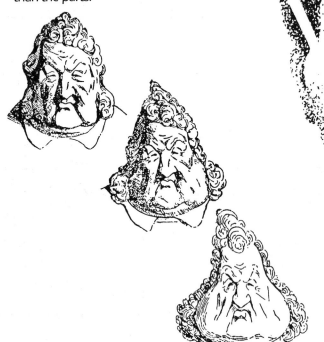

Distortion by imagination
Above, a caricature of Louis-Philippe by a 19th-century artist. Cartoonists have a strong influence on how we remember a person's face. Once seen as a pear, Louis's face can never again appear in any other form.

TASK 105
Caricature
Try to do a caricature of your own self-portrait. This is a very difficult task and most of us fail to see the striking features of our own faces.

Distortion by exploration
Above, distortion achieved by cutting up photostats of the drawing on page 44 and playing with the new arrangement of parts.

TASK 106
Distortion by experiment
Cut up newspaper photographs and re-arrange the parts.

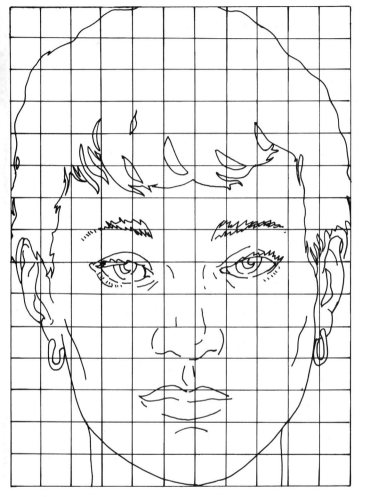

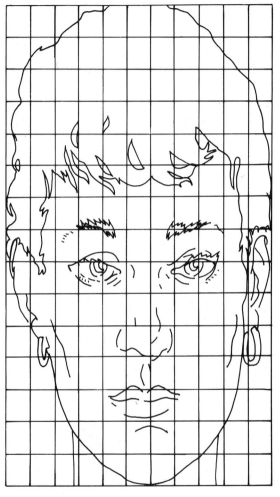

Distortion by geometry
Below left to right, the horizontal and vertical relations of features can be very slightly distorted by widening or narrowing either of the axes, or by bending one axis.

TASK 107
Square-up a photograph
Draw a new, distorted, grid and replot the features.

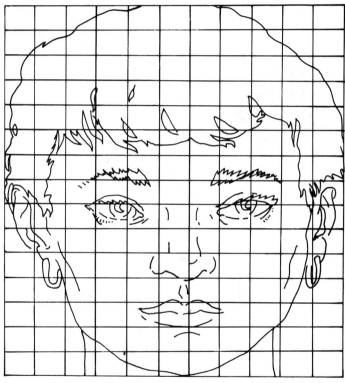

Distortion by tradition
Left, a series of profiles in which a 19th-century artist imagines that intellectuals idiots, workers and others have characteristically different features.

TASK 108
Collect character types
Collect portraits of poets, murderers and politicians and, to disprove the 19th-century idea, ask friends to guess the character of each example.

© DIAGRAM

60 Expression

Facial expressions reveal our thoughts. The muscles of the face are contorted with our emotional responses. Artists enjoy adding expressions to a drawing because they project to the reader the subject's thoughts.

Eternal symbols
The simple picture for joy and misery. These clown-like designs can be applied to more detailed drawings.

TASK 109
Pulling faces
Sit in front of a mirror and express, and then sketch happiness or sadness.

Expressing emotion
Left to right, three artists descriptions of:
Happiness – by the English 18th-century artist William Hogarth.
Anger – by the Japanese 18th-century artist Katsukawa Shunko.
Despair – a drawing study of a stone carving.

TASK 110
Angry photographs
Collect newspaper and magazine examples of people expressing anger.

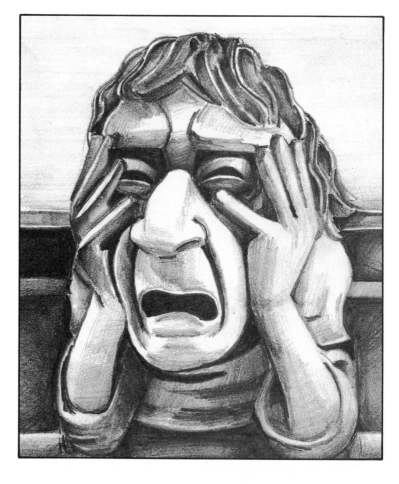

TASK 111

Distortion
Copy a large photograph of a face and, while drawing, try to change the expression on the face.

Facial expressions
Right, twelve drawings of the facial contortions produced to express emotion.

TASK 112

What are they thinking?
Below, these five drawings illustrate some typical responses. What are they?

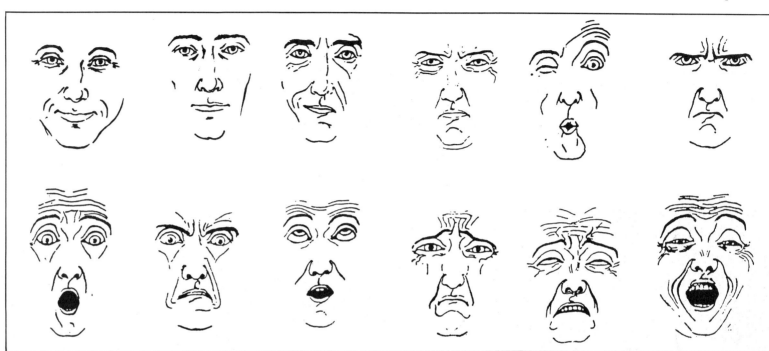

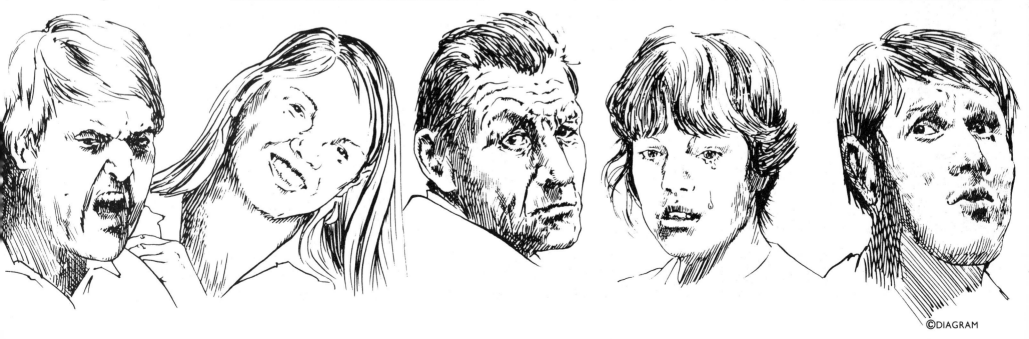

©DIAGRAM

The final ingredient within your drawing is your emotional response to the subject model – your subjective responses. This magical element comes naturally and should be the result of the interaction between you and your subject.

Achieving success
Right and opposite, four drawings by masters of the art. The first is by a young man who copied a photograph of a rock musician hero. The second is a self-portrait by Kathy Kollwitz. The third is an emotional response by the 20th-century artist Ben Shahn. The final drawing is by one of the world's greatest portrait draughtsmen, the 16th-century painter, Hans Holbein.

TASK 113
Subjective responses
Collect examples of artists' works which express their emotional responses to their subjects.

TASK 114
Objective/subjective
Re-evaluate your drawings to try to discover whether they contain an element of your emotional responses to the subject.

TASK 115
Emotional response
Copy any picture in this book which you think shows the artist's subjective responses. Another way to do this is to copy the drawing you like best in the book as this reflects your subjective responses.

TASK 116
Admiration
Draw the person you most admire – either from a photograph, or from a personal study of them sitting in your presence.

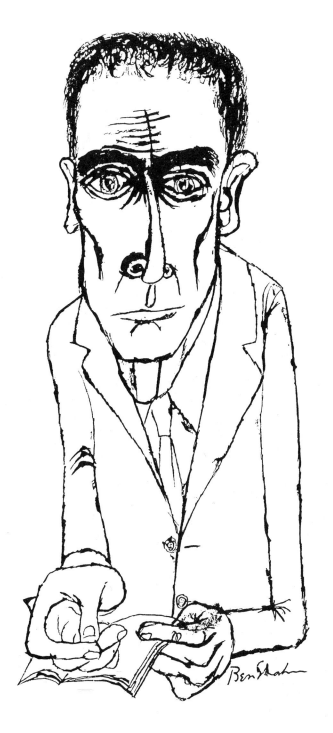

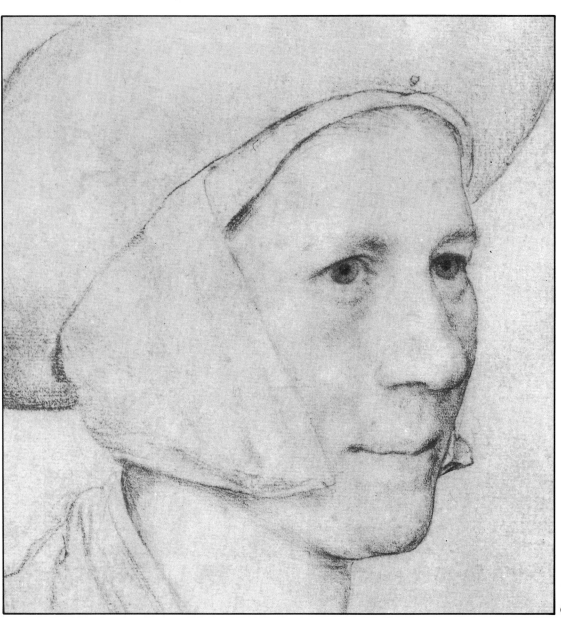

64 Review

Portraits
These drawings are by Jane, aged 11, 16 and 20.

TASK 117
Review
Collect all your tasks into one portfolio and store safely.

TASK 118
Mount and present
Cut a card mount of one of your better drawings and offer it as a gift to a friend.

TASK 119
Buy a drawing
Buy an artist's drawing or print from an exhibition, gallery or art shop.

TASK 120
Promise
Promise yourself to do a drawing of yourself at least once a year. This task is very good for the Christmas holiday times. During those days you can spend a restful two hours doing a self-portrait.

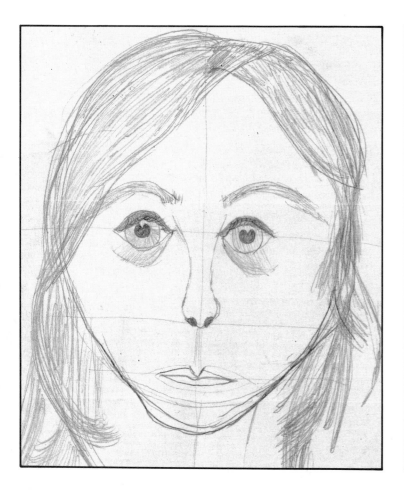
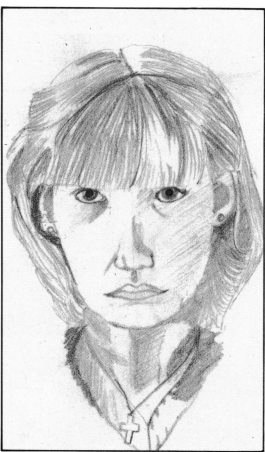
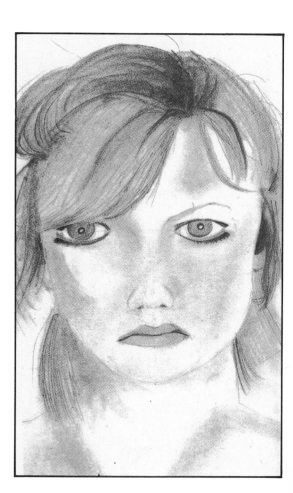